IMAGES
of England

BRIDGWATER

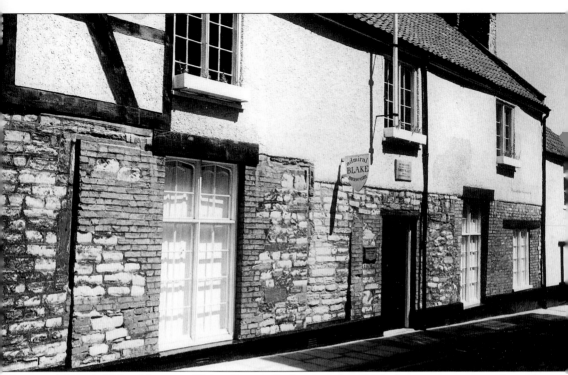

Admiral Blake Museum, Blake Street, Bridgwater. In 1926 the museum opened in the birthplace of Robert Blake, General-at-Sea. Housing collections of local and maritime history, art and archaeology, the museum also features the seventeenth century with the life of Robert Blake (1598-1657), and the Monmouth Rebellion of 1685. Admiral Blake Museum is part of Sedgemoor District Council.

IMAGES
of England

BRIDGWATER

Compiled from
The Collections at Admiral Blake Museum

TEMPUS

Proceeds from the sale of this book will contribute to the development of the photographic collections at Admiral Blake Museum

First published 1998, reprinted 1998, 2003

Tempus Publishing Limited
The Mill, Brimscombe Port,
Stroud, Gloucestershire, GL5 2QG

© Sedgemoor District Council, 1998

British Library Cataloguing in Publication Data.
A catalogue record for this book is available from the British Library.

ISBN 0 7524 1049 0

Typesetting and origination by Tempus Publishing Limited
Printed in Great Britain by Midway Colour Print, Wiltshire

Contents

Acknowledgements 6

Introduction 7

1. Setting the Scene 9

2. From Penel Orlieu to Eastover 13

3. From the Riverside to Castle Street 29

4. Around West Street 39

5. On the River 49

6. Keeping the Faith 65

7. School Days 75

8. Working Days 81

9. Sport and Leisure 99

10. Markets and Fairs 107

11. Pageant and Parades 117

Acknowledgements

The illustrations in this book are taken from the photographic collections of The Admiral Blake Museum. Some originally came from the official sources of town, rural and district councils, but many have been given or loaned to the museum over the years. A big thank you must be given to all those individuals and families (too numerous to mention here) who have donated and loaned photographs to the museum, since its opening in 1926.

Introduction

Listed in the Domesday Book as the small settlement Brugie, there has been much debate over the origins of the town's name. The holder of the manor was Walter of Douai and one suggestion - Walter's Bridge - can be discounted, because he almost certainly did not build a bridge across the Parrett. A more recent interpretation has been that the name derives from the Old English for a gang plank placed between ship and shore - brycg - or even from the Norse term for quay or jetty - bryggia, but even this has been disputed. Whatever the origins of its name, the fledgling town was well situated on an area of raised land on the banks of the River Parrett. The agricultural community developed around the river crossing and began to operate as a river port and commercial centre.

In the year 1200 King John granted his loyal supporter, William Brewer, three charters to operate in the town. These charters did much to determine the character of the town over the next seven centuries. Brewer was granted permission to build a castle and to create a borough outside its walls. He also built the Great Bridge across the river. The river crossing was now protected by a stronghold. The bridge also had the effect of forcing ships to dock and transfer their cargoes to barges waiting up river. The third charter dealt with markets and fairs, which were to be a valuable source of income and amusement for the town.

By the fifteenth century the town had become a thriving port with some 300 houses. The main export was cloth from the woollen industry of Bridgwater and other Somerset towns.

The castle however, did not live up to its expectations and by the seventeenth century had become little more than the manor house for the landowners, the Mortimer family. However, during the Civil War it was to see

some action during the Siege of Bridgwater in 1645. As the garrison of the Royalist Army, the castle and town were besieged by Thomas Fairfax and the New Model Army after the Battle of Langport in July of that year. Only a few of the town's timber buildings were left unscathed and the Governor, Edmund Wyndam, was forced to surrender. Much of the castle was demolished and by the eighteenth century a small part of the keep was all that remained, at what is now King Square.

In the eighteenth century the commercial activity of the town expanded. From the 1720s the Duke of Chandos involved himself in numerous interests, including shipbuilding, glass making and property development. However it was the burgeoning brick and roofing tile industry that was to preoccupy the town over the next 200 years.

The nineteenth century brought with it numerous developments in transport links from the railways, port and canal. The Bristol and Exeter line opened a railway station to the east of Bridgwater in 1841. There was much subsequent development on that side of the town, resulting in the construction of a parish church, St John the Baptist, for use by the new residents. The river port was still important, especially for coastal trade, and the Bridgwater Docks were opened in 1841. However, the influence of the Severn Tunnel and the port of Bristol could not be ignored and the Bridgwater port soon fell into decline.

In the twentieth century the once thriving brick and tile manufacturers felt the effects of two World Wars on their overseas market. But more importantly, there was also the threat of competition from the producers of concrete products. As the industry declined and was eventually swept away, the economic base of the town shifted to a wider range of manufacturing industries.

Many of the changes in the town, from the buildings and streets, to the industry and river trade have been recorded by local photographers and artists - professional and amateur. The earliest photographs in the museum's archives date from the 1860s. One wonders what John Chubb, the eighteenth-century artist who recorded the town in such fine detail, would have made of the 'instant' picture. Much of the photographic collection at The Admiral Blake Museum is available for research purposes and a variety of images are on display. However, it is by no means a complete record. Historic and more recent photographs are continually being added to the collection. This volume has presented an excellent opportunity for many of the photographs and postcards to be published for the first time. We hope you enjoy sharing these memories.

Sarah Harbige
Museums Officer

One
Setting the Scene

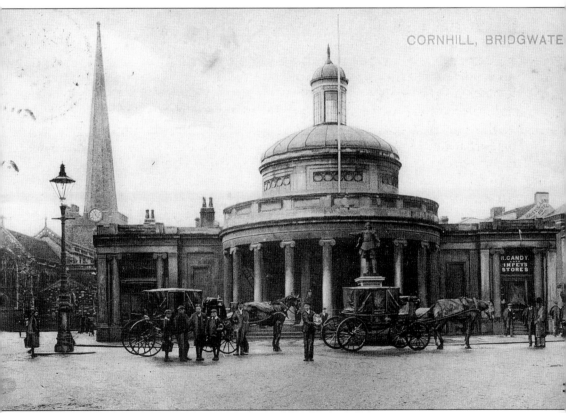

Cornhill, Bridgwater, c. 1900.

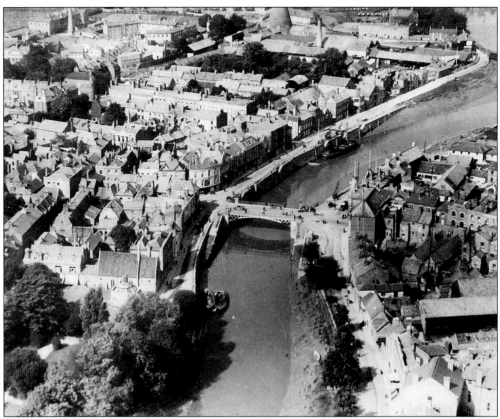

Bridgwater, *c.* 1930. The town of Bridgwater is situated on either side of the River Parrett. In this view many familiar features of the town can be seen, including the Town Bridge and the distinctive dome of the library next to Blake Gardens. To the north can be seen the unique shape of the glass kiln, built for the Duke of Chandos in about 1723 and demolished in 1943.

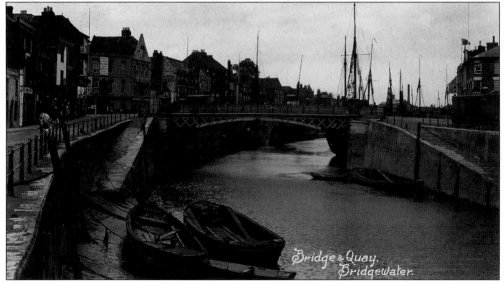

The bridge and quay, Bridgwater, *c.* 1905. The bridge was opened in 1883 (see p. 124).

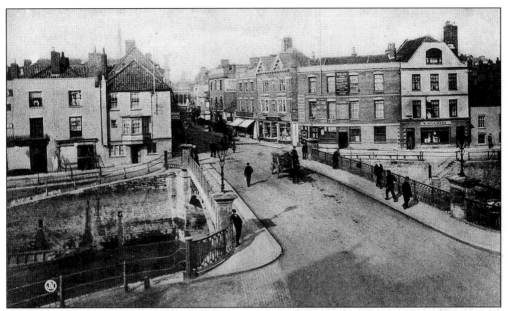

The bridge and Fore Street, Bridgwater, c. 1910. Since mediaeval times the bridge has been an important crossing point on the Parrett. Its position was significant in establishing Bridgwater as a port and centre for trade.

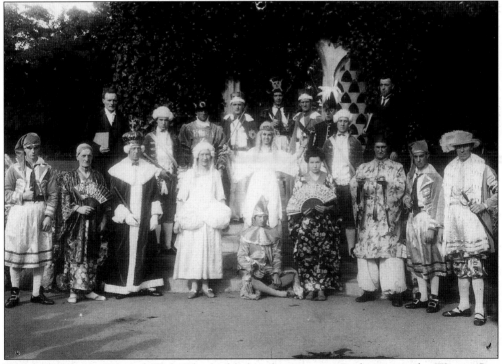

Devonshire Arms Carnival Club. The highlight of any year in Bridgwater is the Winter Guy Fawkes Carnival (see pp 123-128).

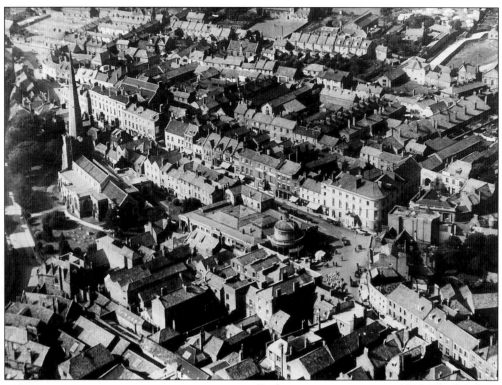

Bridgwater town centre, c. 1930. The Market House at Cornhill is situated in the centre of the town, with the Parish Church of St Mary to the left. Below the Market House, at the top of Fore Street, a flock of sheep can be seen being driven to market.

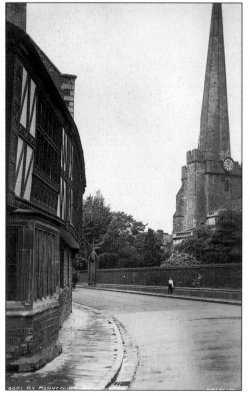

A view of St Mary's Church spire, from St Mary Street, c. 1905.

Two

From Penel Orlieu to Eastover

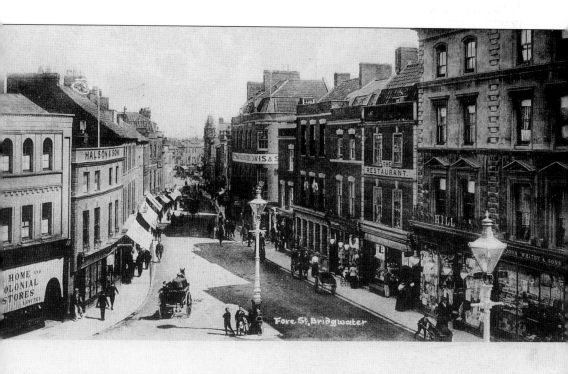

Fore Street, Bridgwater, c. 1900.

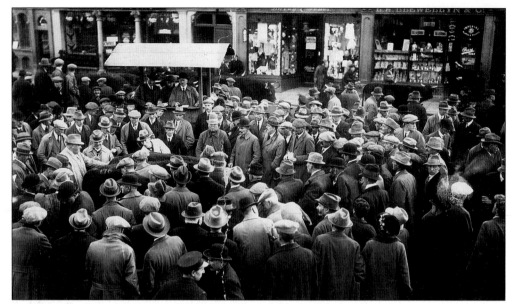

Cattle Market, Penel Orlieu, c. 1935. Crowds assemble for the cattle sale. From the early days of the 1200 Charter, cattle were sold at Le Orfaire, a triangular piece of ground inside the West Gate. Cattle continued to be sold at the Cattle Market, built in 1877 in Market Street, until its closure in 1935.

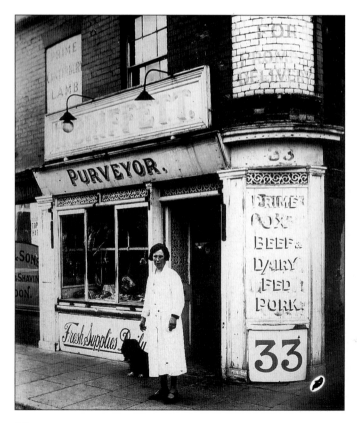

Henry Briffet, butchers, Penel Orlieu. Mabel Briffet stands outside the shop she ran after her husband's death in 1931. She died in 1952.

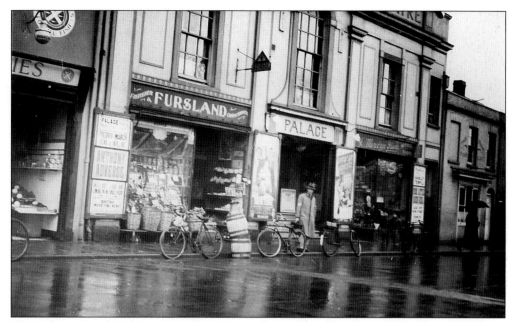

The Palace, Penel Orlieu, 1936. Opening as the Empire Theatre in 1916, the cinema was renamed The Palace in the following year by its new owner, Mr Albany Ward. In 1936 the film *Anthony Adverse*, starring Olivia de Havilland and winner of four Oscars, was showing.

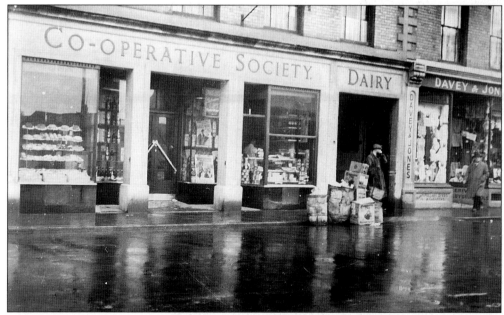

The Co-operative Dairy, Penel Orlieu, 1936.

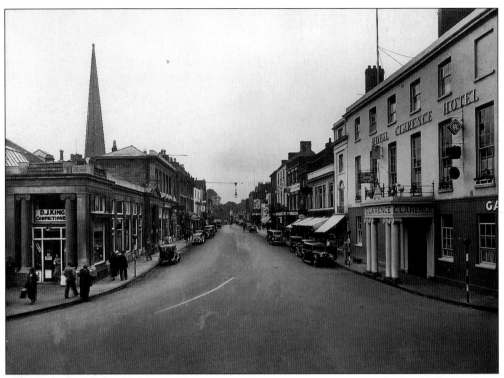

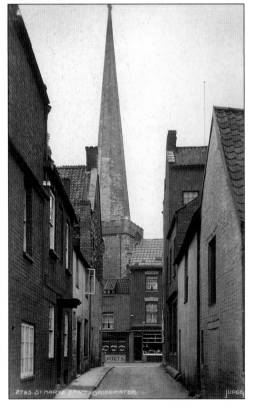

High Street, mid 1930s. The Royal Clarence Hotel was opened in 1825. It was built on the site of two small inns, The Angel and The Crown. It was also known as Longhurst's Hotel, after its owner Mr Longhurst in 1866. At the time of the photograph, however, the hotel was part of the Trust House chain. The coat of arms which can be seen above the door was removed from the town's first iron bridge when it was demolished in the 1880s.

Mansion House Lane, c. 1905.

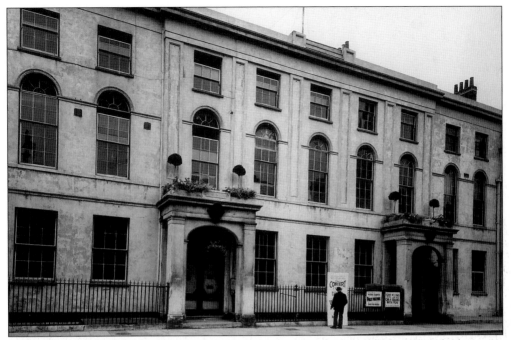

Bridgwater Town Hall, High Street. A lone pedestrian reads publicity for a forthcoming concert. The building, designed by Richard Carver in 1823, was built as part of a scheme to improve the crowded street of the 1820s. A shambles ran down the centre of the High Street.

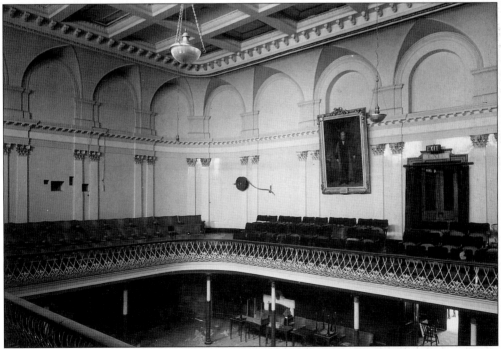

Bridgwater Town Hall, interior. The Town Hall was used as a theatre for concerts, music hall revues and, from 1930 to 1950, as a cinema. In the left hand wall of the balcony can be seen the openings through which the films were projected.

17

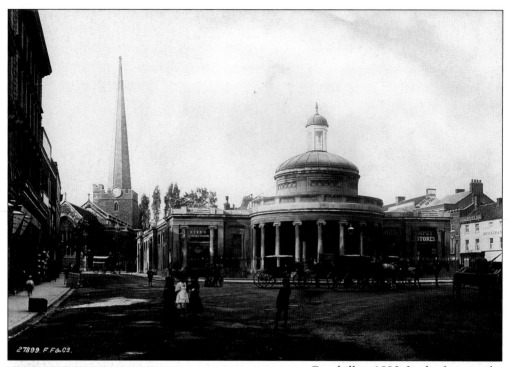

27899. F.F&C9.

Cornhill, *c.* 1890. In the fourteenth century the eastern end of the market area outside the Castle's main gate was known as Cornchepyng. The name is still with us today in Cornhill. The railings which surround the Market House were removed in September 1895.

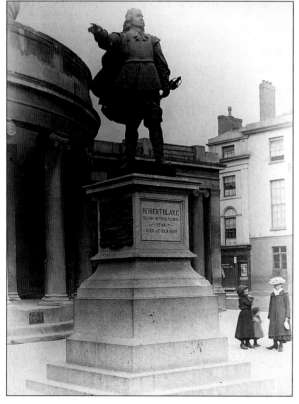

ROBERT BLAKE
BORN IN THIS TOWN
1598
DIED AT SEA 1657

Blake statue, Cornhill. The statue was erected by public subscription in 1900. Designed by F.W. Pomeroy, it celebrates the life of the town's most famous citizen, Robert Blake. Blake was born in 1598 and served Bridgwater as MP in 1640. However, it is for his exploits as General-at-Sea in the Navy of the Commonwealth that he is best remembered.

Cornhill, *c.* 1950. The market buildings were built between 1791 and 1875, with the Market House and Dome being completed in 1826.

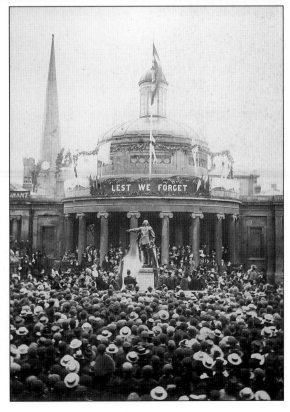

Unveiling the statue of Blake, 4 October 1900. The ceremony was performed by Lord Brassey, who also unveiled a plaque at Blake's birthplace on the same day (see page 34).

19

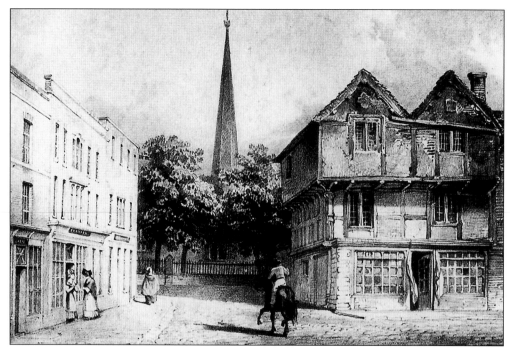

Cornhill, Bridgwater, after John Chubb (1746-1818). The timber-framed buildings were removed to make way for the new Market House in 1826. On the left two women can be seen exchanging news in the doorway of Thompson's ironmongers store. Thompson's opened here in 1797.

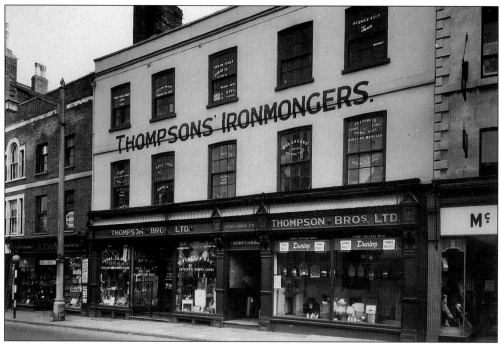

Thompson Brothers Ltd, 5 Cornhill, c. 1950. The business moved on to Market Street before becoming established in Mount Street, where they continue to trade today.

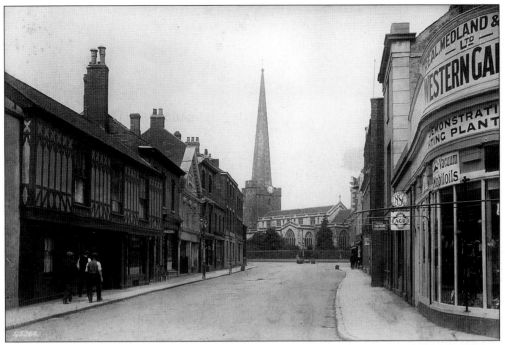

St Mary Street, *c.* 1930; a view that has changed little, from the corner of Dampiet Street towards the church. However, there are no vehicles to be seen on this empty street at 10.30 in the morning.

St Mary Street, *c.* 1960; the view from Silver Street to the junction. The presence of a single motor car is particularly remarkable.

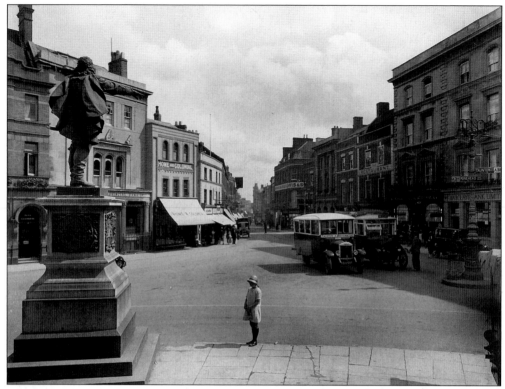

Fore Street, from the Cornhill, c. 1930. The stores on the left were built over what once was the castle moat.

Fore Street, from the Cornhill, c. 1960. Marks and Spencer, to the left of the photograph, opened on 2 March 1934.

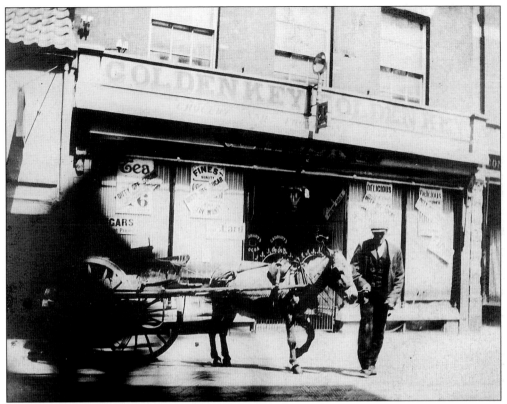

Fore Street, 1908. The Golden Key Stores, owned by Messrs Hook, was later known as World Stores.

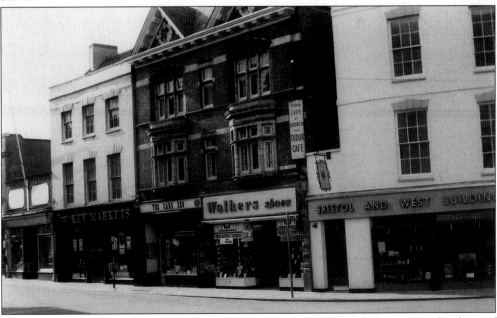

Fore Street, 1965. The Golden Key Stores are now trading as Key Markets, part of a chain of grocery stores.

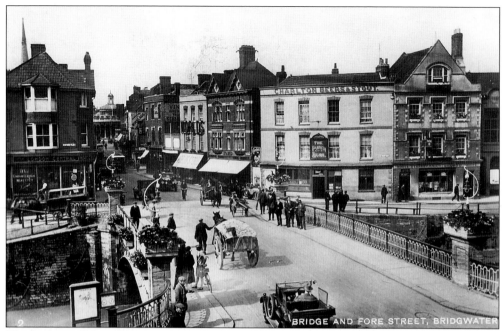

The bridge and Fore Street, c. 1930. A cart can be seen transporting clay across the bridge. The Punch Bowl Inn is on the corner of West Quay. The landlord was Horace Prew. This public house closed in 1964, to be replaced by a building society. Next door is the Starkey, Knight and Ford pub, The Fountain. Their brewery at Northgate closed in 1964.

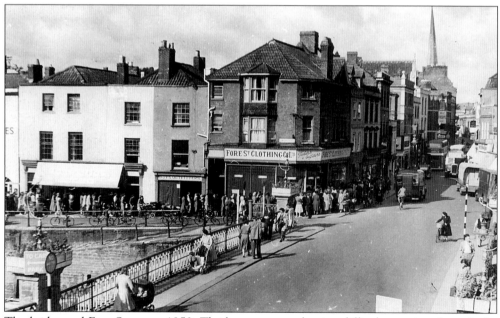

The bridge and Fore Street, c. 1950. The buses seem to having difficulty passing through the narrow street.

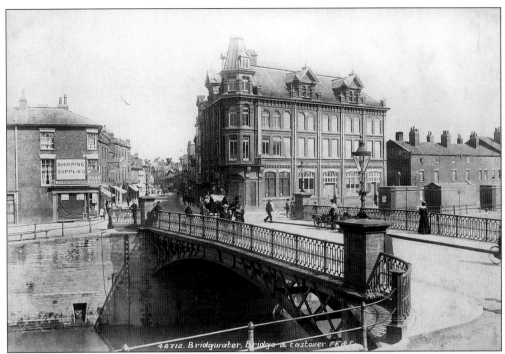

The bridge and Eastover, *c.* 1902. The imposing brick YMCA building on the corner of Eastover and Salmon Parade was opened on 16 October 1887, at a cost of £2,490. When the George Williams Memorial Hall, as it was known, was demolished, the YMCA moved to new buildings in Albert Street, in 1968.

George Williams founded the Young Men's Christian Association in 1859. Williams was born at Dulverton in 1821. He came to Bridgwater to be apprenticed to W.H. Holmes, a draper, whose business was on the south side of the Cornhill.

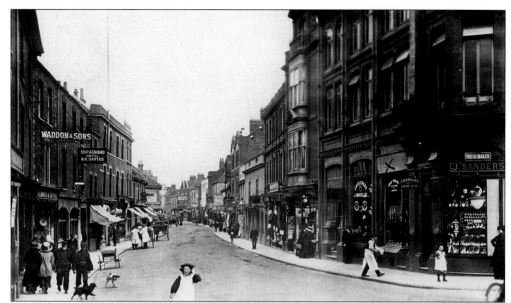

Eastover, *c*. 1910, viewed from the Town Bridge. J. Saunders, jeweller, is one of the shops situated in the ground floor of the YMCA building on the right. The sender of this postcard marked Waddon's cycle shop next door for the attention of the recipient, Miss E. Bray of Exeter.

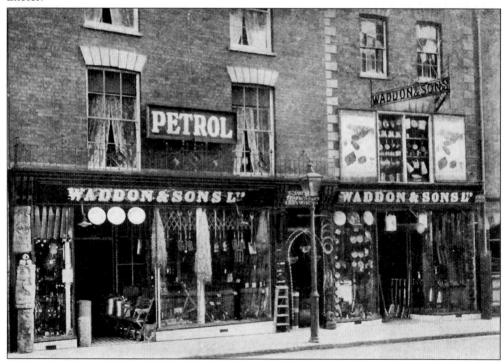

Waddon and Sons, ironmongers, Eastover. Waddons are selling a variety of goods, but they first began trading in the town as rope-makers, the earliest reference being in a trade directory of 1832. The rope-walk, which was destroyed by fire in 1951, was situated behind the store. The road is still called Rope Walk.

Eastover, a bit of old Bridgwater demolished in 1890.

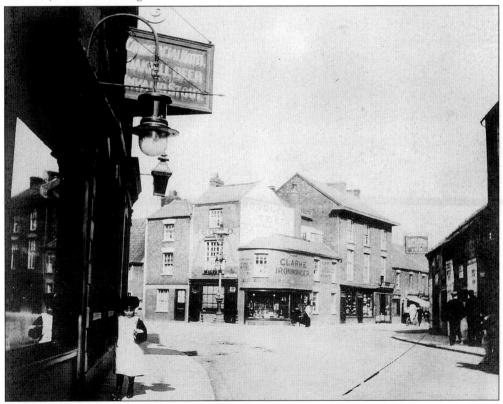

Eastover in 1908, showing the junction of Eastover with Monmouth Street and St John's Street.

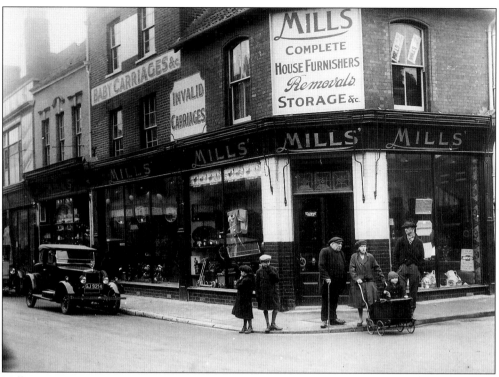

Mills' stores, Eastover, in 1930. Mills household furnishers were located at 51 and 53 Eastover.

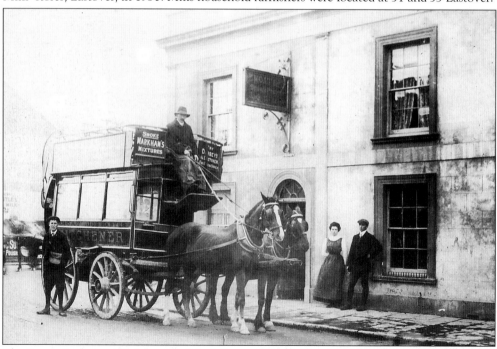

The Steam Packet public house, St John's Street. The Phillips family were the landlords of this Ashton Gate Brewery house, with Frank being the last tenant in 1958/9, when the pub closed its doors for the last time.

Three
From the Riverside
to Castle Street

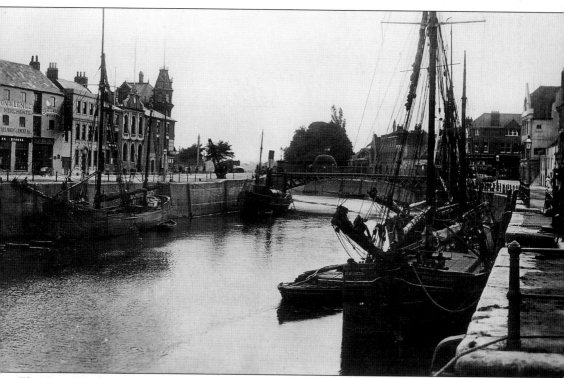

The Quay, Bridgwater, *c.* 1910.

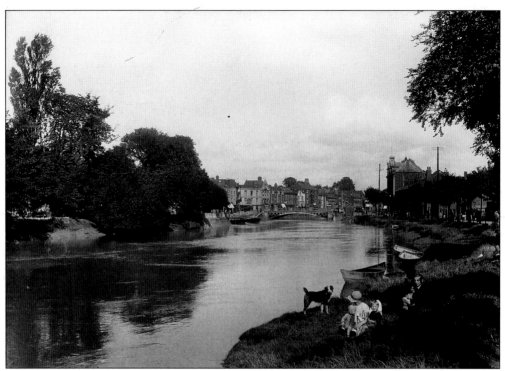

The river bank at Salmon Parade, *c.* 1930. A family enjoys the view from Blake Gardens to the Town Bridge.

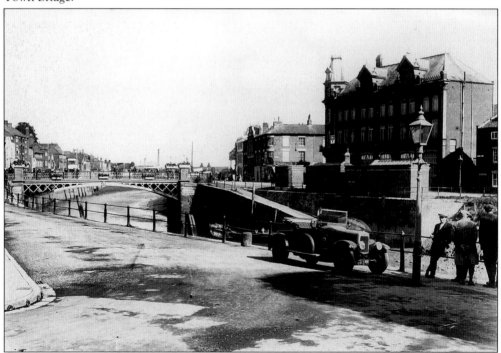

West Quay and Salmon Parade from Binford Place, *c.* 1930. The small buildings in front of the YMCA building are toilet blocks, built in 1868.

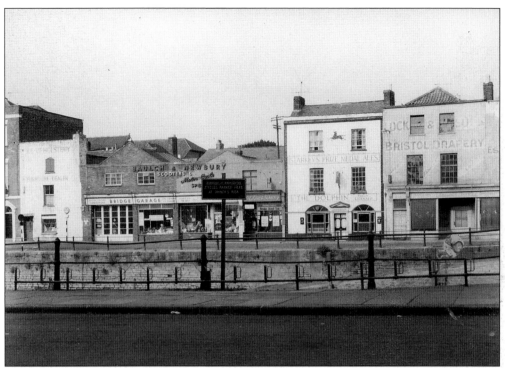

Binford Place, July 1964, the year that the Starkey, Knight and Ford pub, The Dolphin, closed. Mr Hobbs was the last landlord to call time. This row of buildings was demolished to make way for a modern development of flats and shops.

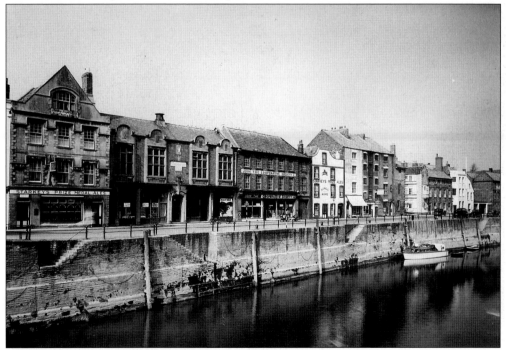

The warehouses and pubs of West Quay, c. 1950.

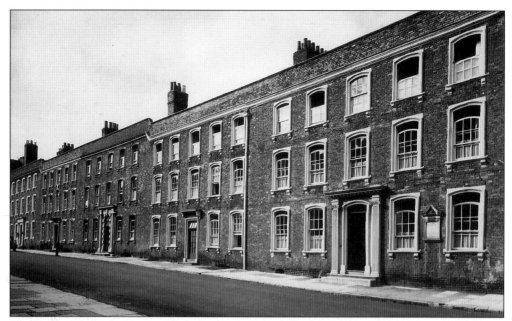

North side of Castle Street. This elegant street was built as part of the Duke of Chandos's scheme for the town in the early eighteenth century. Chandos bought what was then the Castle Estate and employed Benjamin Holloway, whom he had met in Bath, as his architect and builder. The houses were built between 1724-1734, but did not sell well. The Duke and Holloway were in dispute over a number of things, including the quality of his work. Chandos sold his interests in the town in about 1734.

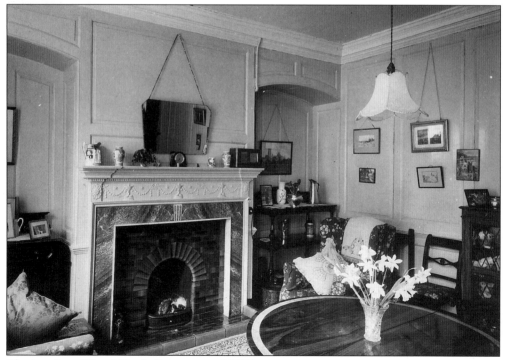

The interior of No. 6 Castle Street around 1950.

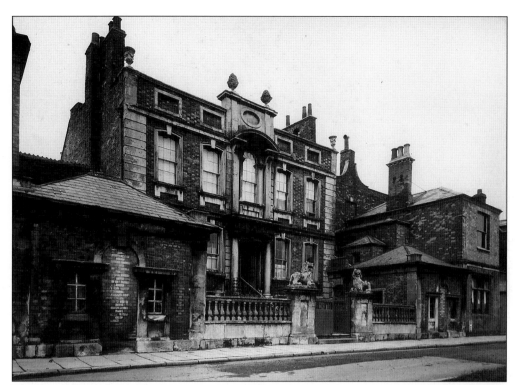

The Lions, West Quay. This imposing building was built between 1725-1730 by Benjamin Holloway for his own use. He may have fallen out with the Duke of Chandos over the house, as he was suspected of using materials from Castle Street in its construction.

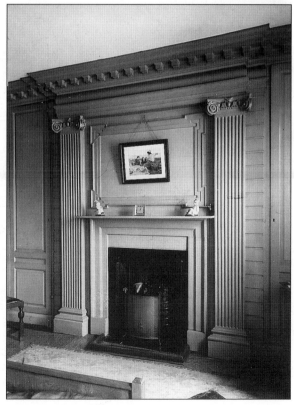

The interior of The Lions.

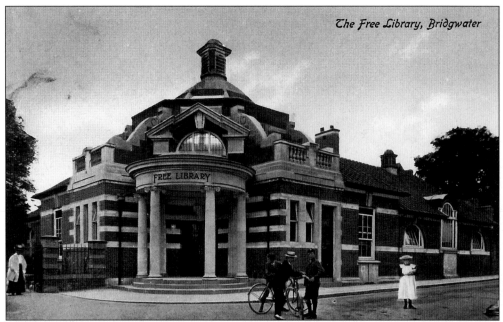

The Free Library, Bridgwater

Bridgwater Library in 1906. The library was opened by the mayor, Henry W. Pollard in 1906. The first librarian, Mr Henry Croker, earned £75 per annum.

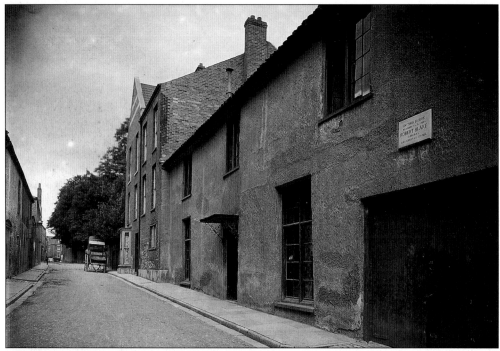

Blake House, Blake Street, c. 1900. The house was built in the sixteenth century. By 1598 it was owned by Humphrey Blake, father of Robert, who was probably born in the house in that year. The buildings were bought for the town's museum, by Bridgwater Borough Council, from a Mr William Kitch in 1924. The plaque above the double doors was unveiled by Lord Brassey in October 1900.

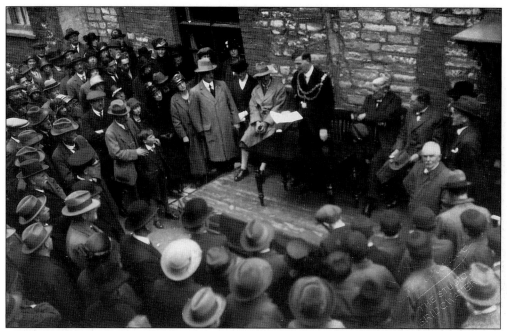

Admiral Blake Museum, opening ceremony, 16 April 1926. The opening was performed by the Mayor of Bridgwater, Alderman Walter Deacon. Standing in the crowd are Mrs D. Wills and her mother. The small boy in the front is Charles Matthews.

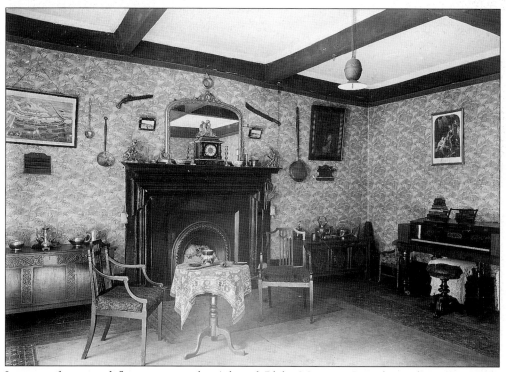

Interior of a ground floor room in the Admiral Blake Museum. Is it the parlour or an early museum display?

Blake Gardens, *c.* 1905. In 1898 Binford House, the home of Mr R.C. Else, was purchased by Bridgwater Corporation for a new library building and public gardens. The park also includes the former gardens of Blake House. The public gardens were opened on 9 August 1902 by the mayoress, Mrs Manchip, as part of the town's coronation celebrations.

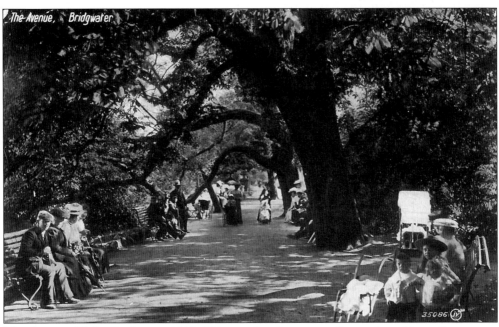

The Avenue, Blake Gardens, *c.* 1910. This popular chestnut walk was the subject of numerous postcards of the park produced at this time.

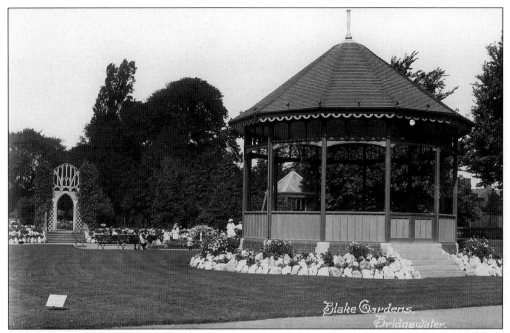

The bandstand in Blake Gardens, *c.* 1910. The long awaited bandstand was opened by Mrs Wills, mayoress, on 29 July 1908. The decorative gothic archway from the former gardens of Binford House can also be seen.

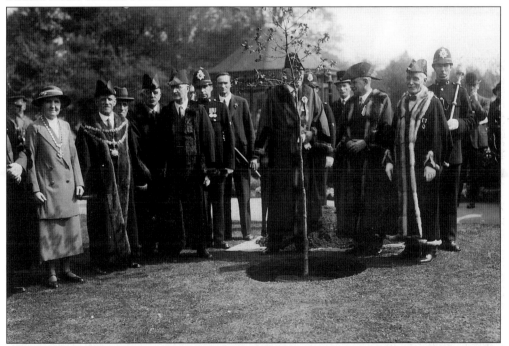

Planting a tree in Blake Gardens, *c.* 1934-1936. From left to right the dignitaries are: the mayoress Mrs Reed; the mayor Mr Reed; Revd Thomas; Mr Bryer; Mr Deacon; Mr King; Mr C. Symons (behind the tree); Mr Berry and Mr Haggett, behind whom stands a Bridgwater Constable holding one of the town's historic maces.

King Square, the site of the main buildings of Bridgwater Castle. These houses were built between 1807 and 1830.

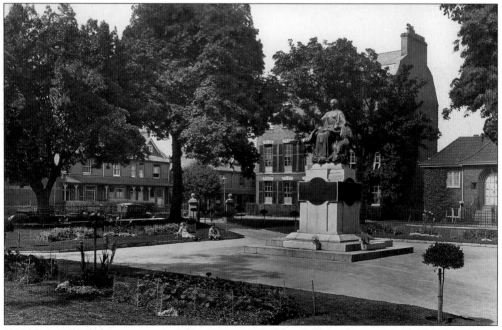

King Square and the war memorial, *c.* 1930. Raised by public subscription the memorial was unveiled by the Earl of Cavan in 1924. The statue of Civilisation cost in the region of £2,000. The sculptor, John Angel, emigrated to the USA in 1936.

Four
Around West Street

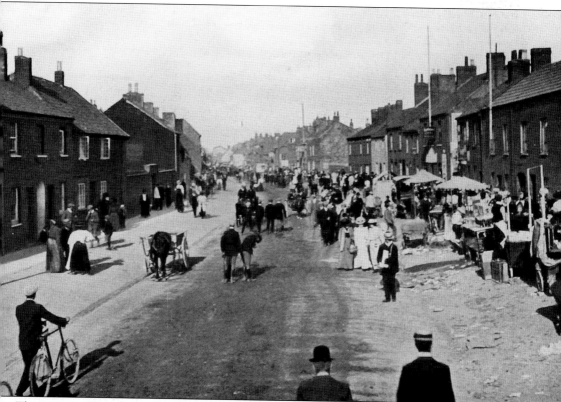

The scene in West Street on St Matthew's Fair Day in 1907.

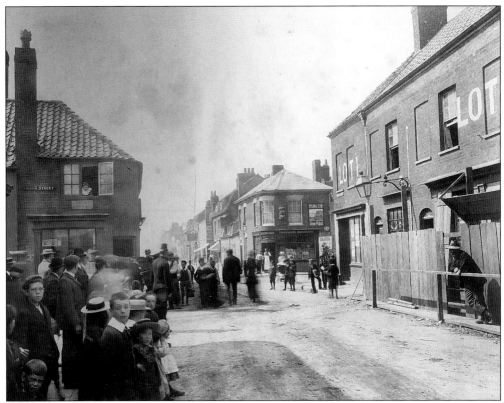

West Bow corner, Monday 19 August 1901. Crowds gather to watch the demolition of buildings at the corner of North Street and Penel Orlieu - a notorious accident spot.

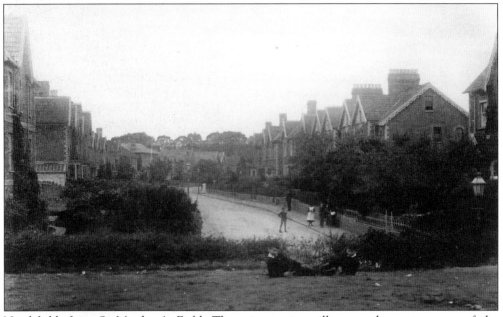

Northfield, from St Matthew's Field. These impressive villas were home to many of the successful tradesmen of the town.

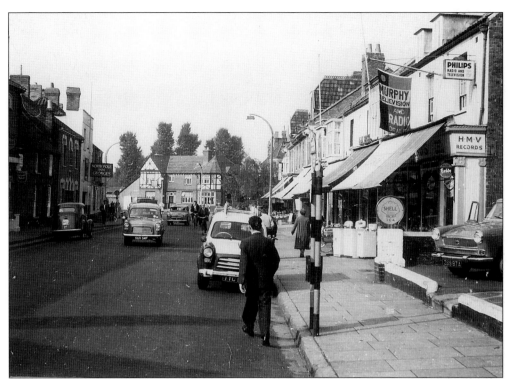

North Street, c. 1960, showing the view towards the Malt Shovel Inn, which was rebuilt in 1904.

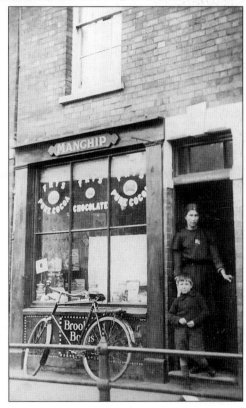

Manchip stores, West Street, in the 1930s.

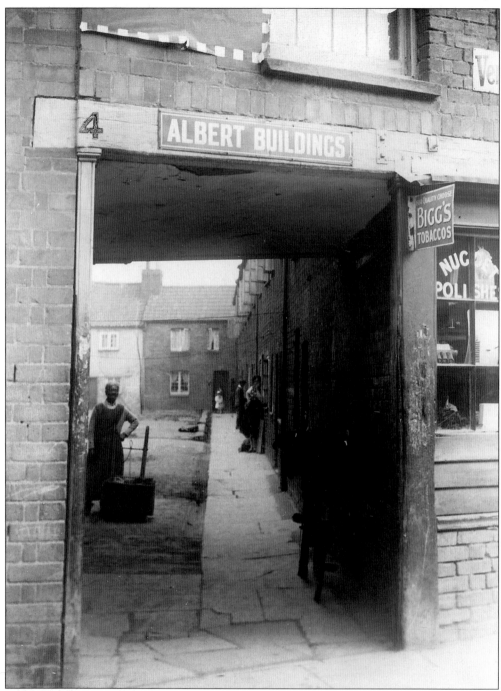

Albert Buildings in the 1930s. Around West and Albert Streets were numerous small courts. In 1897 there were eighty-nine such cottages in West Street and eighty in Albert Street. By the 1930s the Rural District Council had become concerned about living and sanitary conditions, as all the houses had to share facilities. A series of photographs was taken to illustrate the case for demolition, which finally happened some thirty years later. A selection of these photographs is reproduced here.

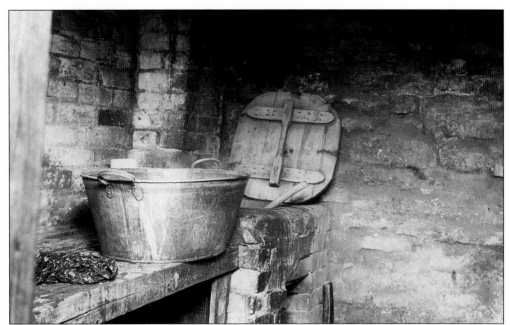

Wash house at No. 7 Court, Albert Street. Cottages shared washing and toilet facilities.

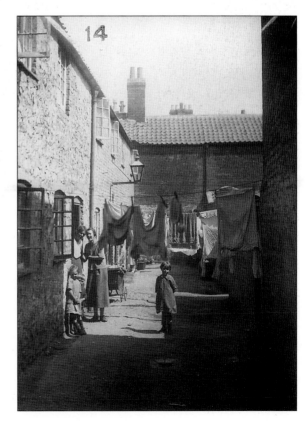

Washday in the courts.

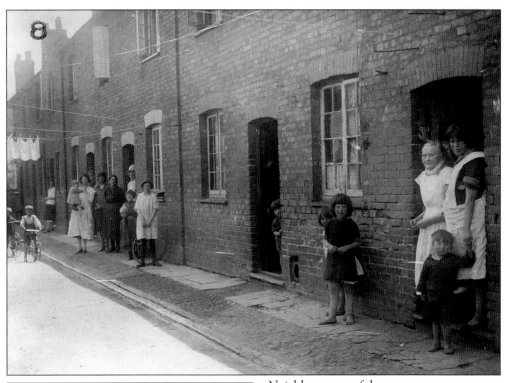

Neighbours out of doors.

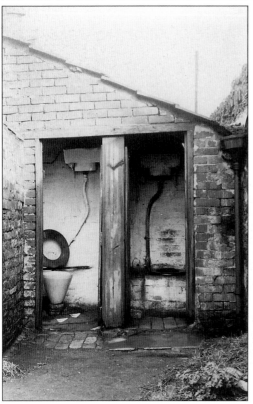

Toilet facilities at No. 5 Court, Albert Street.

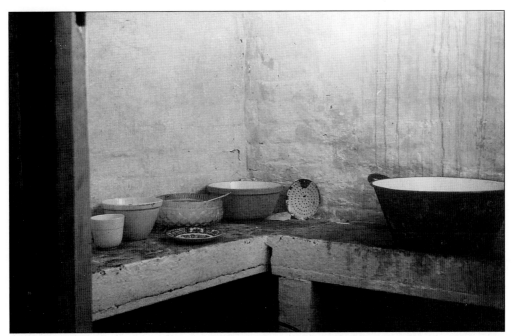

A corner of 'Pockocks Dairy'. George Pockock kept a store at 56 Albert Street.

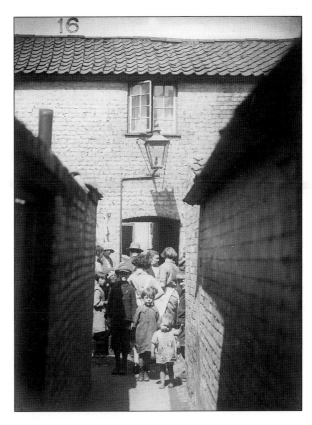

A gathering in the Courts.

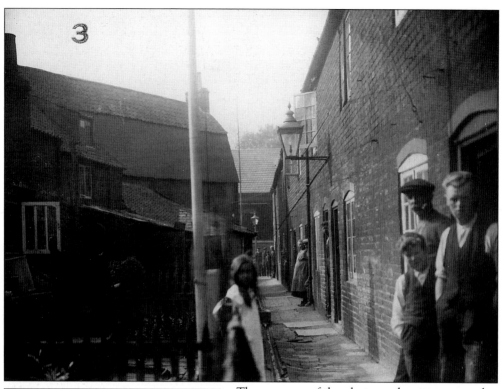

The presence of the photographer attracts much attention from the residents.

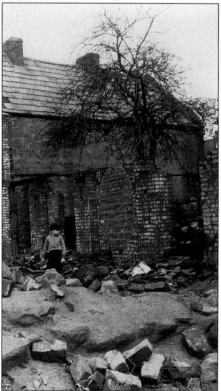

Boys play amongst the disused buildings at the rear of Gloucester Place.

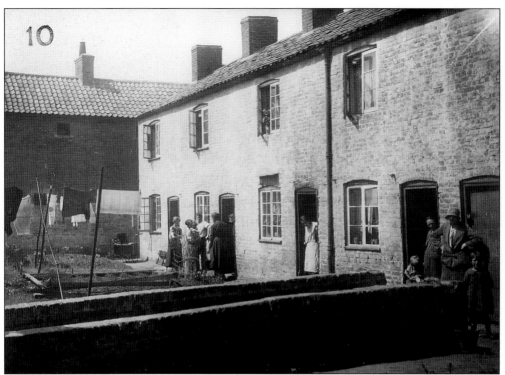

At the Courts again.

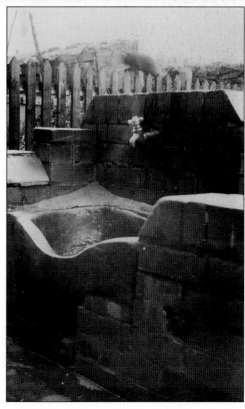

Number 9 Court, West Street. The weekly
wash has left its mark on this sink!

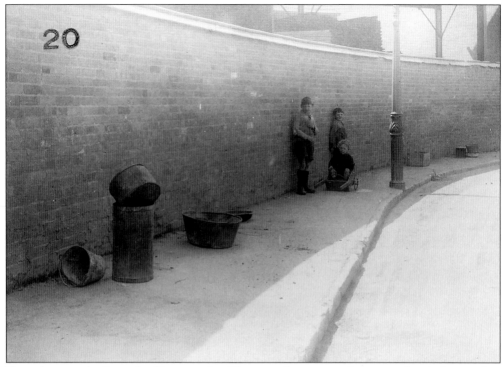

Two photographs from the Courts series. The one above was taken near the timber yard at Northgate on a Saturday morning. The empty receptacles once contained refuse, which has been collected. The photograph below shows scavengers at the refuse tip.

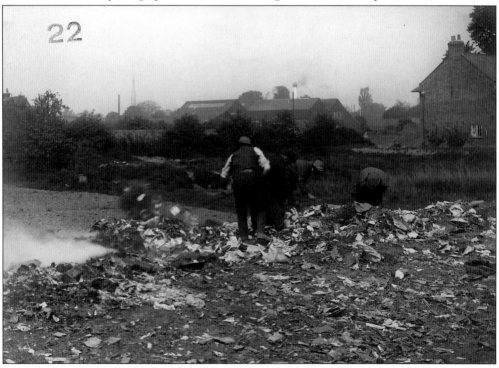

Five

On the River

Invoice from F.J. Carver & Son, Ship Builder, Bridgwater, 1898.

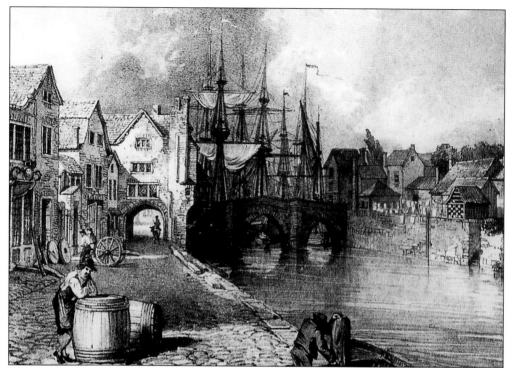

The Stone Bridge, Bridgwater, *c.* 1790, after John Chubb (1746-1818). The first bridge across the River Parrett, it was rebuilt in about 1390 with money from Sir John Trivet. Ships moored down river of the bridge and transferred their cargo into barges at the Langport Slip.

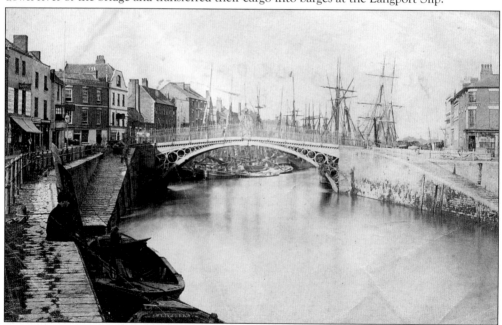

The first iron bridge, *c.* 1880. The bridge opened in 1797, replacing the Stone Bridge. It was cast at Coalbrookdale by Thomas Gregory. Barges can be seen moored at the Langport Slip, which was built in 1488.

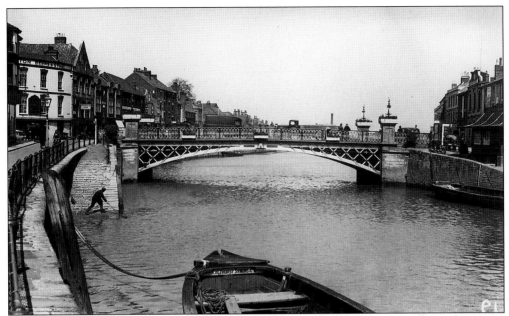

Town Bridge, 5 May 1938. Designed by R.C. Else and G.B. Laffan, the bridge was made by George Moss of Liverpool. The mayoress, Mrs Holland, performed the opening in 1883, whilst her husband was laid up with gout (see page 124).

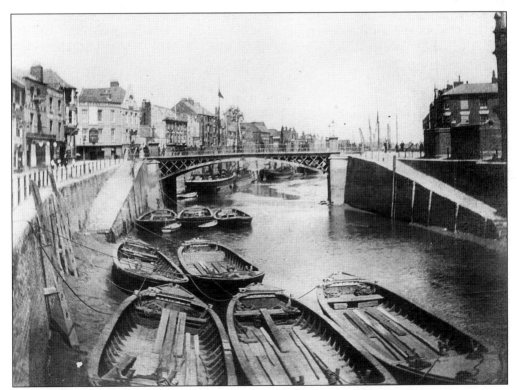

Town Bridge, 1908. The barges could carry cargo weighing up to 20 tons.

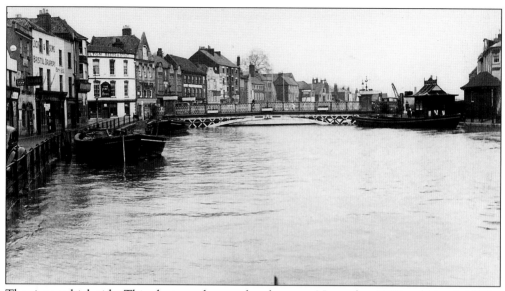

The river at high tide. This photograph was taken between November 1938 and March 1939.

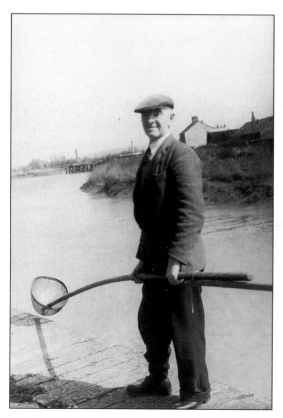

Mr Heal on 14 April 1956. Each year when the elvers make their way up river there is much activity on the banks of the River Parrett. Mr Heal is pictured by Bridgwater Docks, awaiting the day's catch.

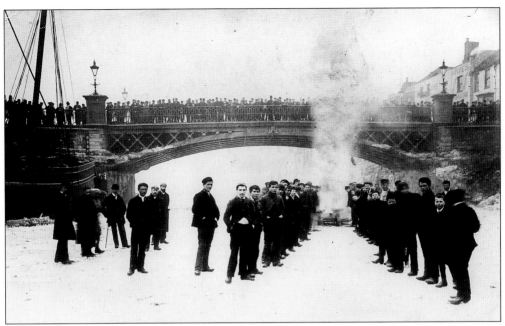

The River Parrett at Town Bridge, 18 February 1895, showing one of a number of spectacular winter freezes from the 1880s. The ice was so solid that fires were lit on it and reportedly oxen were roasted! Photographs of the extraordinary event were sold by *The Mercury* for 1s 6d.

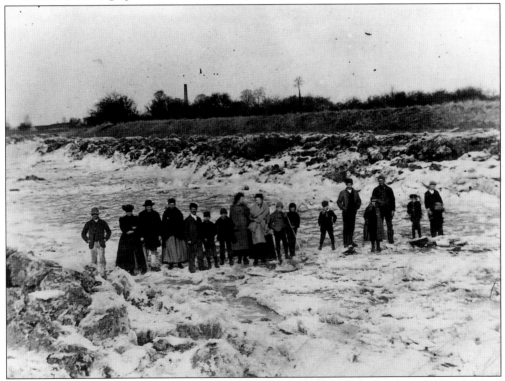

The River Parrett, Northmoor Green, February 1895. Further up river another group gathers on the ice.

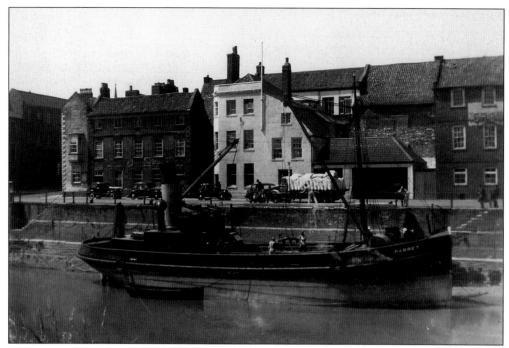

SS *Parret* at West Quay, 1949. The steamship is moored alongside the premises of Peace Ltd, one time owners of the *Parret*, which was broken up in 1959. This vessel was the last to use the quayside for unloading cargo.

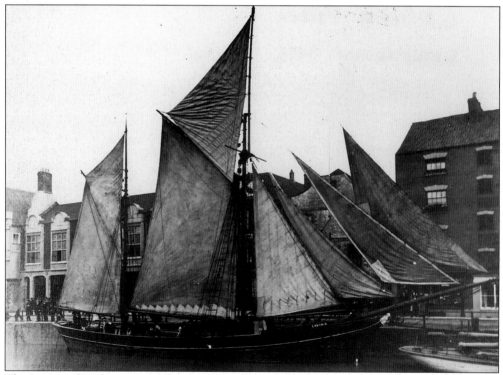

The *Lavinia* of Bridgwater in full sail at West Quay in 1914. She was sunk the following year.

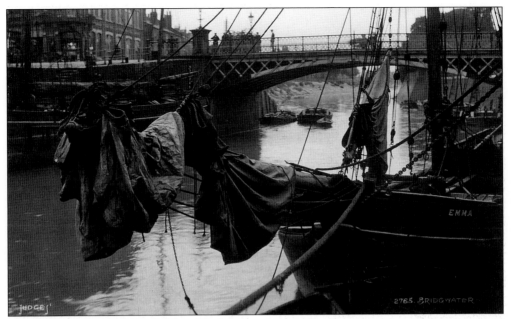

The *Emma*, moored alongside Town Bridge.

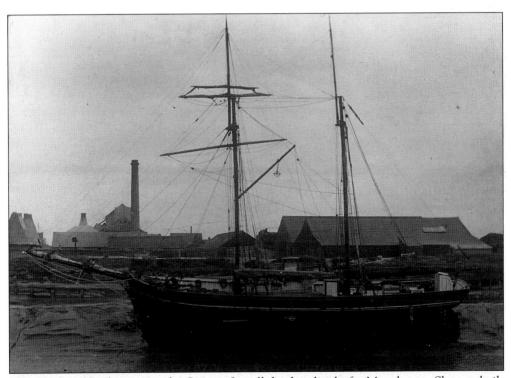

The *Charles* of Bridgwater, under Captain Lovell, loading bricks for Manchester. She was built in 1857 and sunk by a German submarine in 1918. Lovell was taken prisoner.

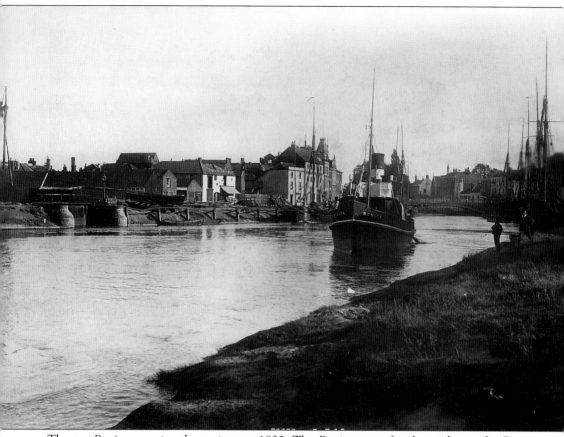

The tug *Bonita* steaming down river, *c*. 1930. The *Bonita* was a familiar sight on the Parrett, under Captain Smart. She was sunk off Liverpool by German aircraft in May 1941. The entrance to Carver's shipyard and dry dock is on the left of the photograph. Francis James Carver was born in 1836 at Chilton Trinity. He was apprenticed to John Gough's shipyard at Crowpill and started his own business in about 1878. The business was carried on by his son Frank until 1921. In the first half of the nineteenth century there were seven yards in Bridgwater; by the 1890s Carver's was the sole survivor.

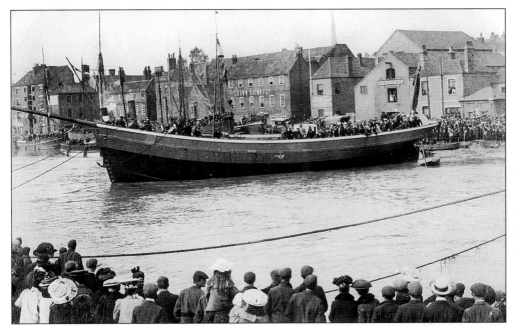

The launch of the *Irene*, 29 May 1907. Built by Carvers, the *Irene* was the last ship to be constructed in Bridgwater. She was commissioned by Messrs Clifford J. Symons, Clifford Symons and William Lee. Lee was to be her future captain. Mrs Barton of Seaton, a member of the Symons family, performed the launching ceremony.

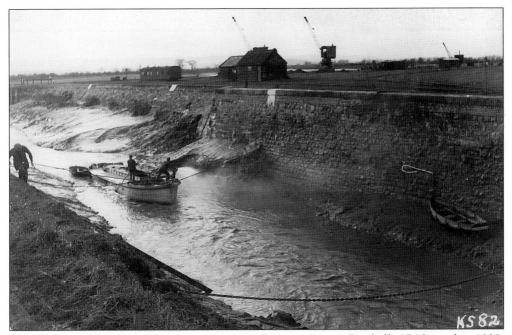

The Eroder and *Persevere* working at King's Sedgemoor Drain, Dunball, 27 November 1938. The *Persevere* was built in 1932 for the Somerset Rivers Catchment Board. Silt was disturbed from the banks of the river by jets of water directed from the Eroder.

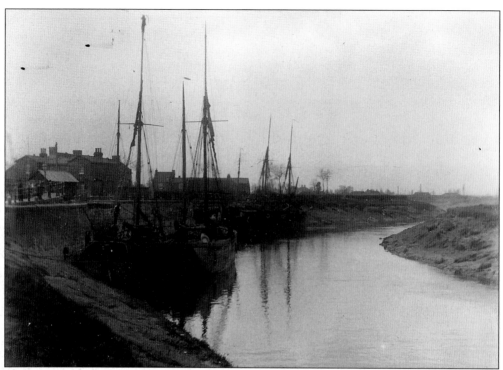

Outside the docks, Bridgwater, 7 March 1914. Four vessels are moored in the river outside the entrance to Bridgwater Docks. Left to right, they are: *Garibaldi* of Gloucester (built Framelode 1884); *Secret* of Bridgwater (built Bridgwater 1867); *Longney Lass* of Bristol (built Bridgnorth 1842); and the *David* of Bridgwater (built Lydney 1836).

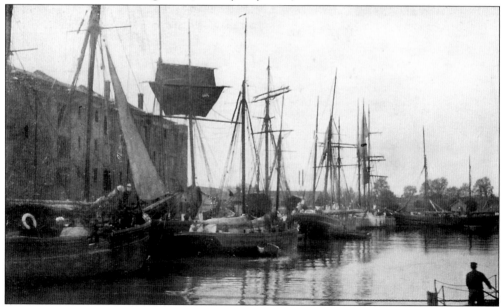

The Docks, Bridgwater. Work began on excavating the Docks, designed by Thomas Maddicks, in 1835. They opened in 1841 and remained in use until 1971. In 1974 they were bought by Somerset County Council and a marina development followed.

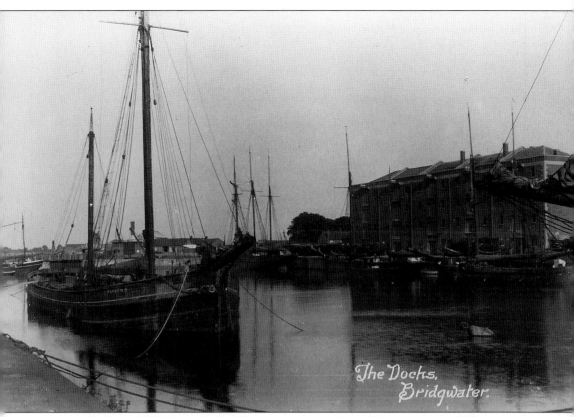

The Docks,
Bridgwater.

Bridgwater Docks, *c.* 1910, showing the view across the docks to Ware's warehouse. There were two entrances from the river into the tidal basin, a ship lock and a barge lock. A second pair of gates controlled entry into the inner basin or dock. The Bascule Bridge crosses this lock.

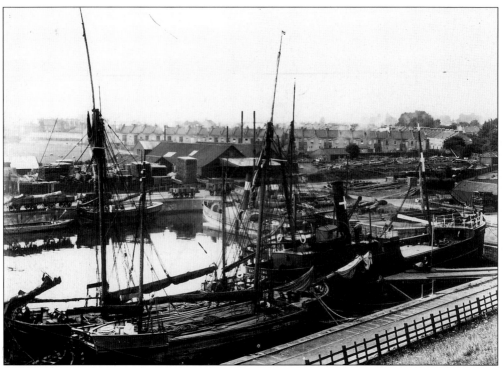

Bridgwater Docks; the view across to the timber yard of George Randle and Son Ltd. Blacklands and sheep grazing in Brewery Field can be seen to the rear.

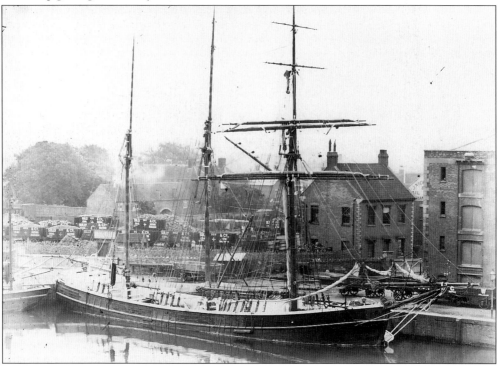

Bridgwater Docks; the view across to Sully's coal yard and Crowpill House.

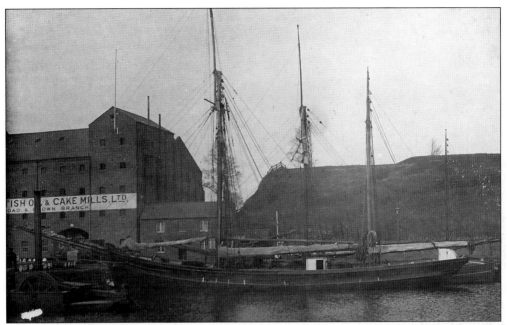

The *Irene* moored at Bridgwater Docks, alongside the Mump and British Oil and Cake Mills. The Mump contained the material excavated from the dock during construction work in 1835.

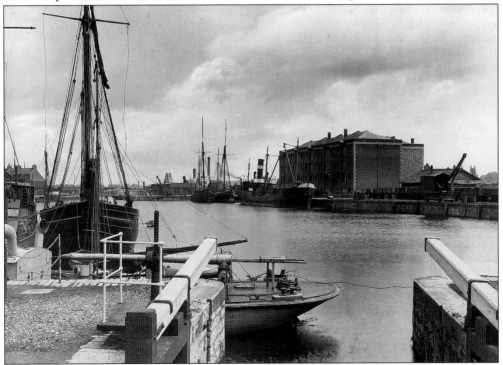

Bridgwater Docks and the canal. Both sailing ships and steam ships are using the dock. In the foreground are the lock gates of the Bridgwater and Taunton Canal, which was was opened to Huntworth in 1827, and extended to the docks in 1839/40. Bought by the Bristol and Exeter Railway in 1866, it closed in about 1907, reopening to pleasure craft in 1989.

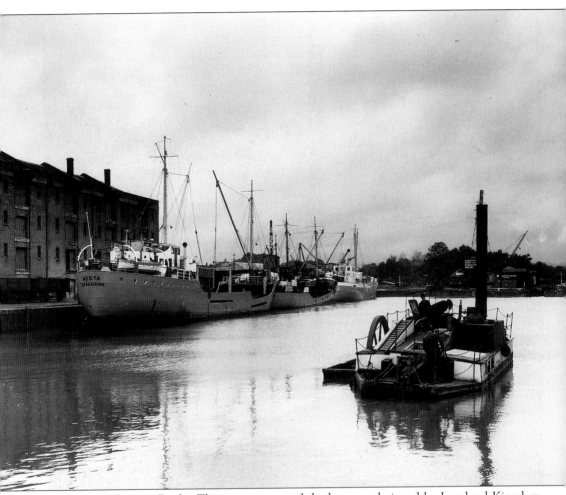

Bertha in Bridgwater Docks. This steam powered dredger was designed by Isambard Kingdom Brunel in 1844. It is now regarded as the oldest steam craft in the country. The dredger scraped and stirred the mud and silt from the docks whilst being chained to the dockside walls.

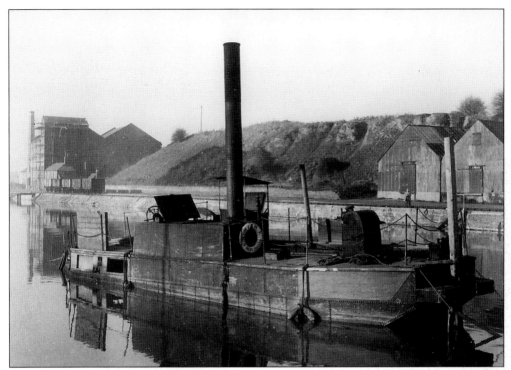

Bertha in Bridgwater Docks, *c.* 1960.

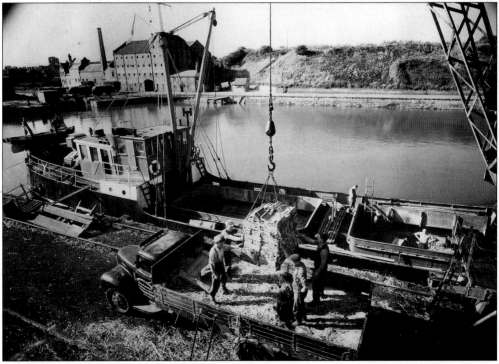

The docks in quieter days. Tiles are being loaded onto a freighter. The lorry belonged to B. Wynn and Sons, coal merchants and general hauliers.

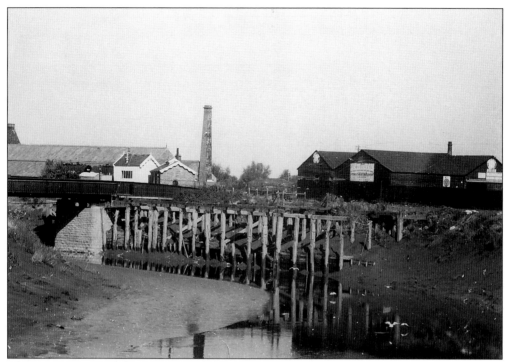

The river, jetties and the Telescopic (Black) Bridge. The bridge carried rail traffic on a branch line to the docks. Completed in 1871, it allowed ships to pass up river by rolling back its middle section.

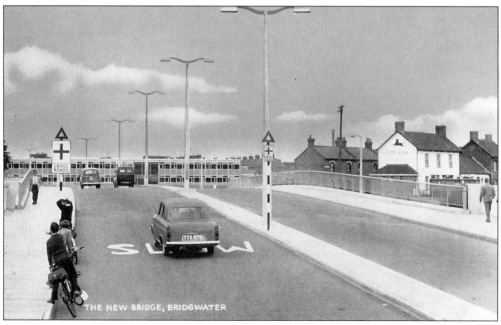

Blake Bridge. On 29 March 1958 a second road bridge opened across the Parrett.

Six
Keeping the Faith

Town Clerk's Office, Castle Street,

Bridgwater, 2nd October, 1876.

THE DEPUTY MAYOR acting during the illness of
THE WORSHIPFUL THE MAYOR requests the honour
of your accompanying him to St. Mary's Church, on Sunday
Morning next, on the occasion of the Annual Sermon being
preached for the benefit of the Bridgwater Infirmary, and
will thank you to meet him at the Council Chamber, at a
Quarter to Eleven o'clock, a.m.

To _Cha Hamblin Esq._

Invitation to a sermon, 1876.

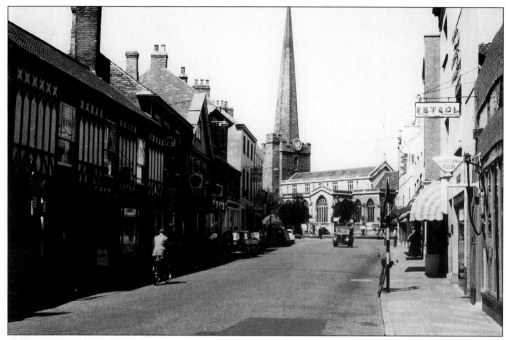

St Mary Street, *c*. 1960. The Parish Church of St Mary has been a focal point in the town since its construction in the thirteenth and fourteenth centuries.

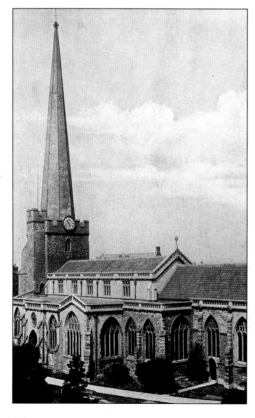

St Mary's Church. The spire is particularly unusual for Somerset. In 1813 a severe thunderstorm caused some damage to the spire. The repairs on this occasion were carried out in 1815 by Thomas Hutchings.

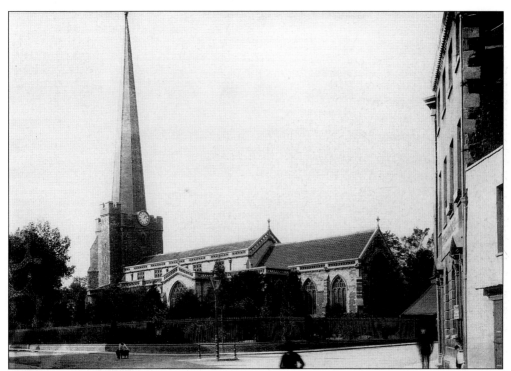

St Mary's Church, which was heavily restored, perhaps controversially, by the architect W.H. Brakspear, from 1849 until 1853.

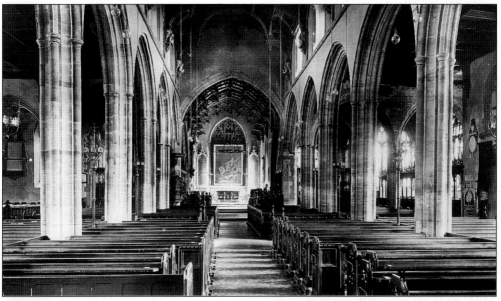

The interior of St Mary's Church, showing the view towards the altar and the painting *The Descent from the Cross*. The pulpit and choir stalls date from the early fifteenth century.

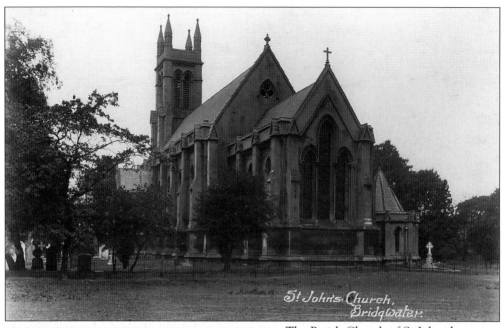

St John's Church, Bridgwater

The Parish Church of St John the Baptist, Blake Place, was consecrated on 17 August 1846 and designed by John Brown of Norwich. It was built to meet the demand from new homes being built between Eastover and the railway.

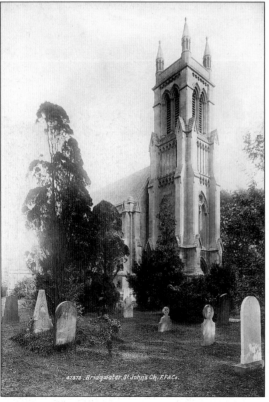

47575. Bridgwater, St John's Ch. F.F&Co.

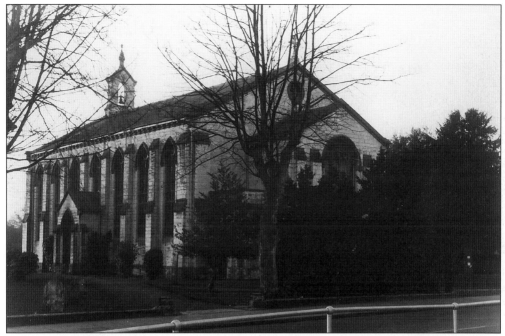

Holy Trinity Church, Taunton Road. Consecrated in 1839, it was demolished in 1958.

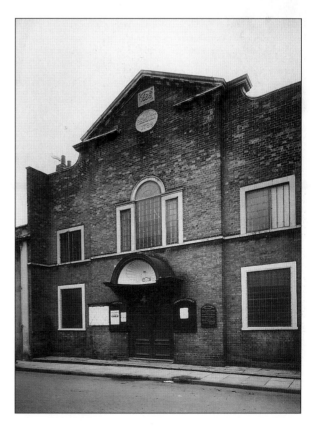

The Unitarian Chapel, Dampiet Street. Dating from 1688, the building was rebuilt in 1789. Bridgwater has a long tradition of non-conformism.

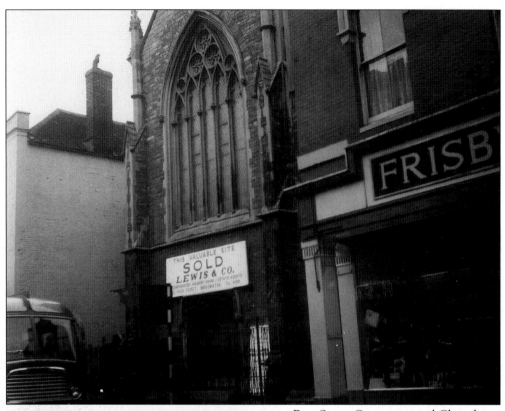

Fore Street Congregational Chapel in April 1964. The site is for sale and the building is soon to be demolished.

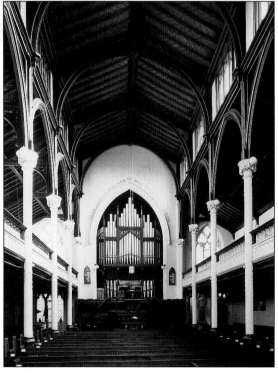

Interior of Fore Street Congregational Chapel. The chapel was built in 1862 and could seat up to 900 people.

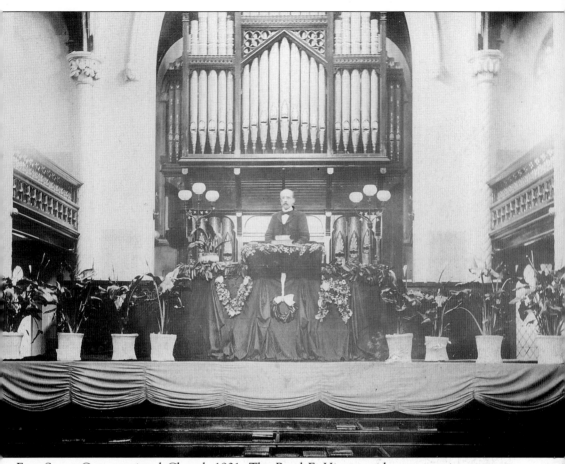

Fore Street Congregational Chapel, 1901. The Revd F. Hirst presides at a service to commemorate the life of Queen Victoria, who died in that year.

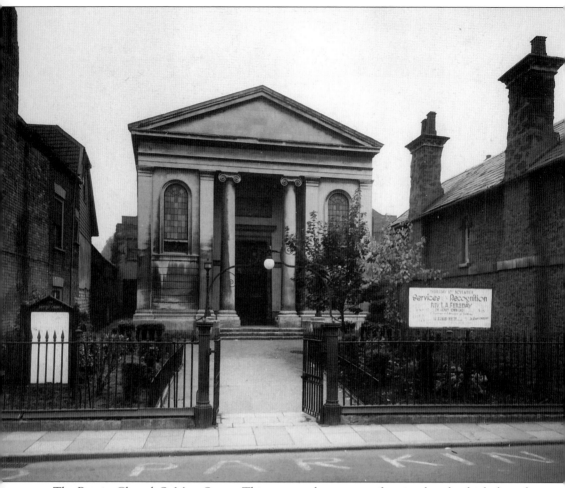

The Baptist Chapel, St Mary Street. This was another non-conformist church which dates from the seventeenth century, a period when believers in the town could exert much influence but also met with hostility for their ideas and activities.

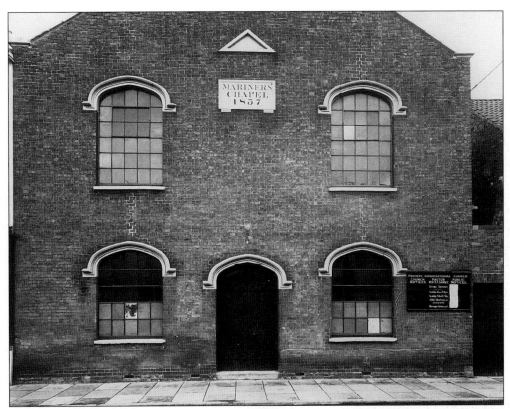

Mariners Chapel, St John's Street, 1959.
The nineteenth century saw a second
wave of non-conformist churches being
built in the town. The Baptists,
Presbyterians and Quakers of Bridgwater
were joined by the Mariners Christian
Church in 1837, as well as the Plymouth
Brethren and three new branches of the
Methodist Church, amongst others.

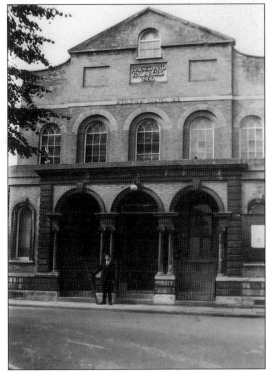

Wesleyan Chapel, King Street.
Built in 1816, it was restored and
enlarged in 1860.

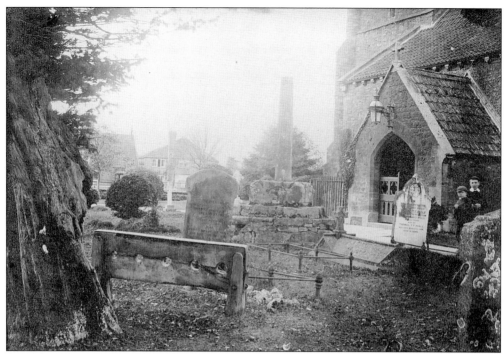

St George's Parish Church, Wembdon. Largely rebuilt in the nineteeth century, the church has a fourteenth- and fifteenth-century tower. There is also a set of stocks and a fifteenth-century cross in the churchyard.

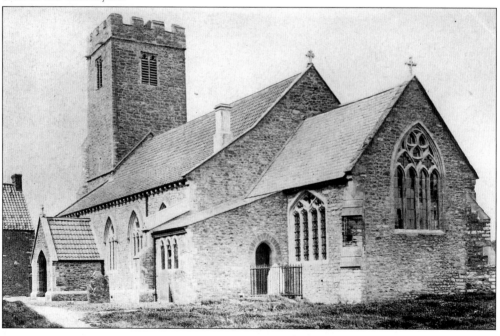

Seven

School Days

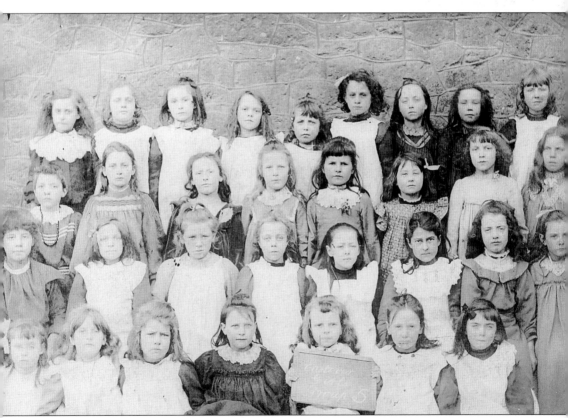

School days at Eastover, *c.* 1910.

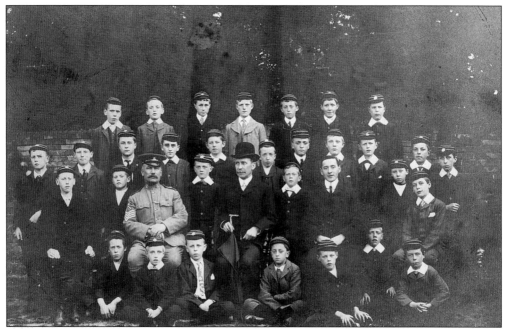

Pupils of the Collegiate School, Bridgwater, 1910. This was a private school for boys run by Brian 'Gaffer' Norris, who sits below and at the centre of this group. Originally located in St Mary Street, the school was situated at Green Dragon Lane by 1938.

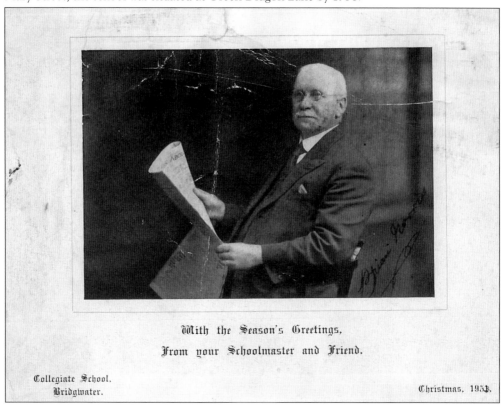

With the Season's Greetings,
From your Schoolmaster and Friend.

Collegiate School.
Bridgwater.

Christmas, 1913.

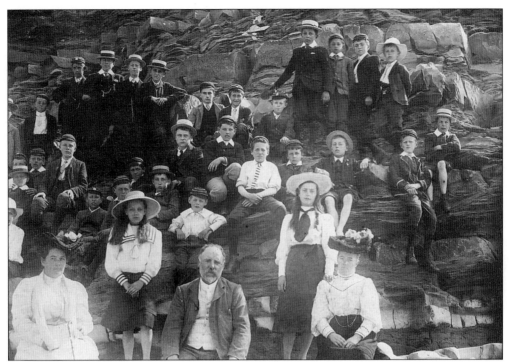

Pupils of the Collegiate School on an outing.

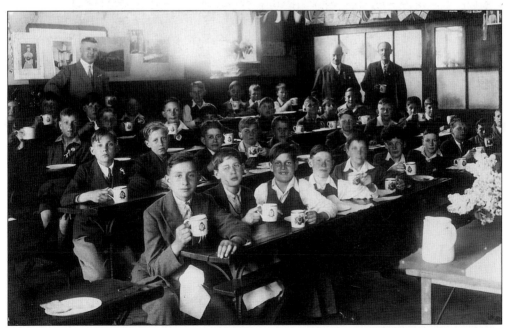

An unidentified class, 1935. Each boy is holding a commemorative mug, presented in celebration of the Silver Jubilee of King George V and Queen Mary.

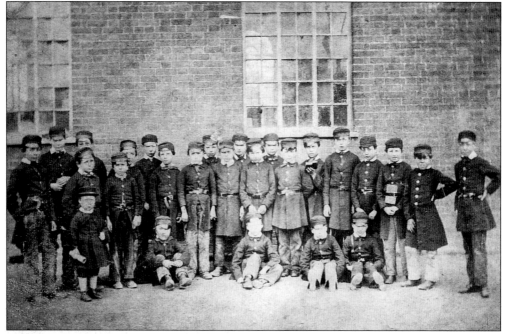

Pupils of Dr Morgan's Grammar School, Mount Street, Bridgwater, in 1864. Dr Morgan's School was founded in 1723. Some 250 years later it merged with the Girls Grammar School to become Haygrove School.

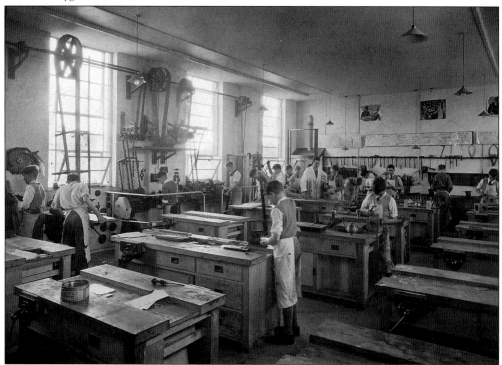

Pupils of Dr Morgan's working in a workshop at the new school buildings in Durleigh Road. The school moved to this site in 1936.

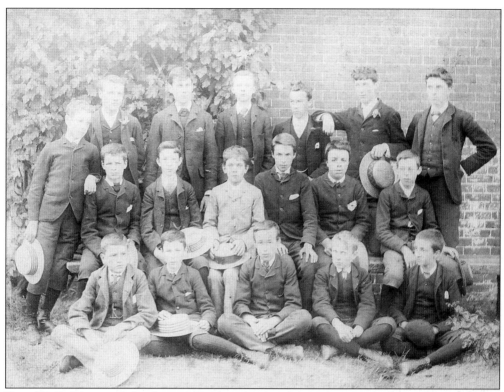

Form VI, Dr Morgans School, in 1887. The school took both boarders and day pupils. From left to right, back row: Wright, Squibbs, Collins, Brown, Rouse, Collins, Best. Middle row: Wright, Rich, Major, Badcock, Roberts, Bond. Front row; Rich, Clatworthy, Holmes, Perrett.

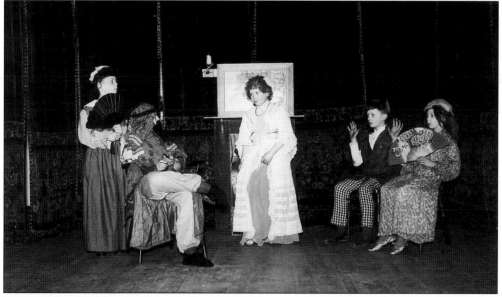

Theatricals at Dr Morgans School, date unknown.

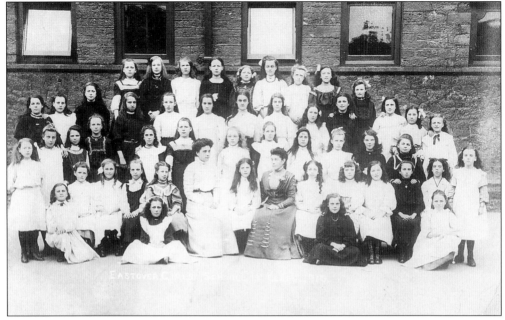

Class I, Eastover Girls School, 1910. Eastover was one of the first elementary schools in the town, together with the St John's, St Mary's (girls) and Albert Street Schools.

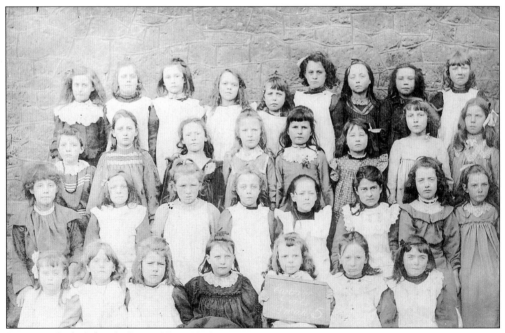

Eastover Girls School, Group V, c. 1910.

Eight

Working Days

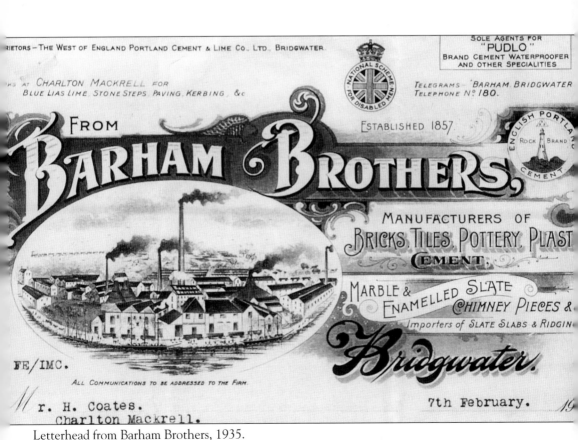

RIETORS — THE WEST OF ENGLAND PORTLAND CEMENT & LIME CO. LTD. BRIDGWATER

RKS AT CHARLTON MACKRELL FOR BLUE LIAS LIME, STONE STEPS, PAVING, KERBING, &c

SOLE AGENTS FOR "PUDLO" BRAND CEMENT WATERPROOFER AND OTHER SPECIALITIES

TELEGRAMS 'BARHAM, BRIDGWATER
TELEPHONE Nº 180.

FROM

ESTABLISHED 1857

BARHAM BROTHERS,

MANUFACTURERS OF BRICKS, TILES, POTTERY, PLAST CEMENT,

MARBLE & ENAMELLED SLATE CHIMNEY PIECES & Importers of SLATE SLABS & RIDGIN

Bridgwater.

FE/IMC.

ALL COMMUNICATIONS TO BE ADDRESSED TO THE FIRM.

Mr. H. Coates.
Charlton Mackrell.

7th February. 19

Letterhead from Barham Brothers, 1935.

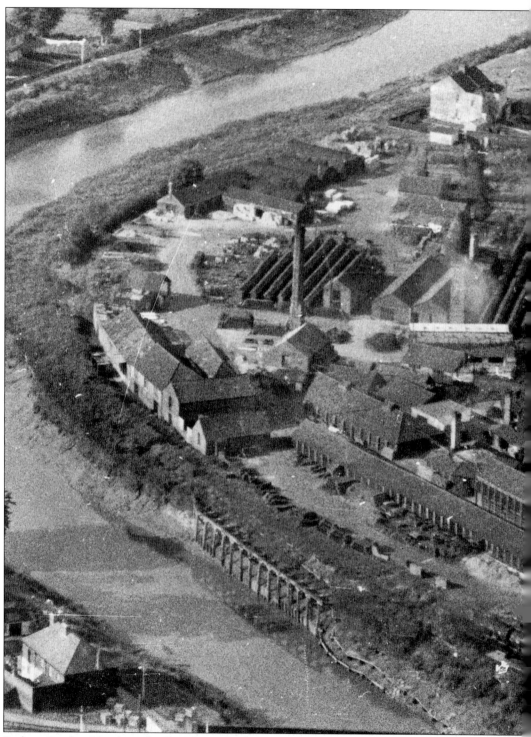

Barham Brothers' brick works, East Quay, Bridgwater. The brick and tile industry was a major employer in the town through the nineteenth and early twentieth centuries. In about 1850 there were sixteen brick yards on either side of the river, within two miles of the Town Bridge.

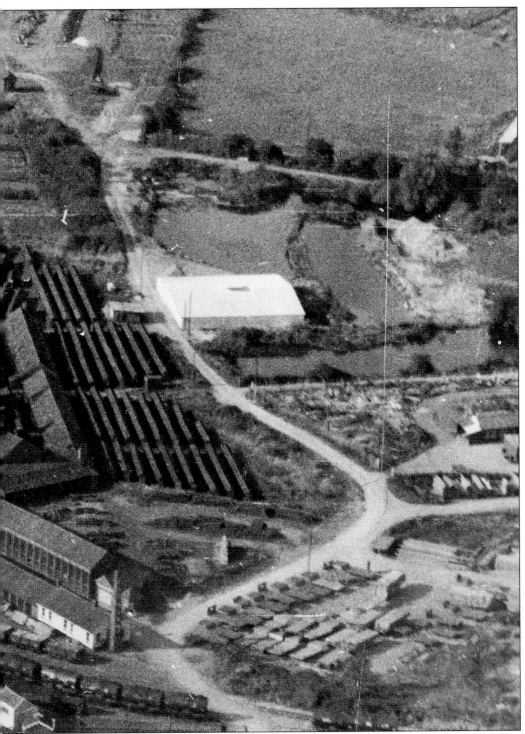

Barhams commenced trading at this time and closed in 1965. In 1880 they employed eighteen men and four boys. The site for the yard was well chosen: it was both next to the river and the branch line of the Bristol and Exeter Railway.

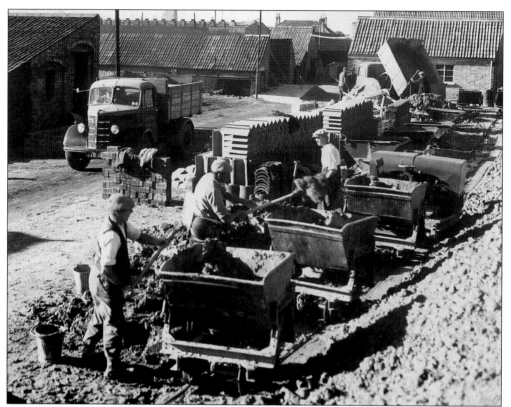

Making tiles - moving the clay at a Colthurst Symons yard. Colthurst Symons & Co. Ltd were one of the largest producers of clay goods, with yards in and around Bridgwater.

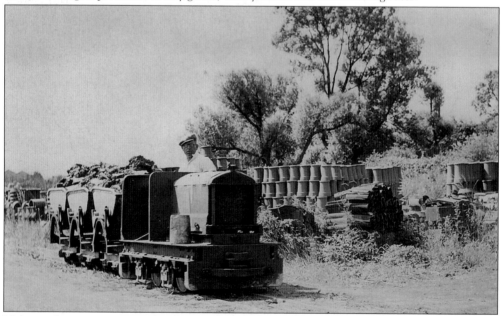

Making tiles - transporting clay from Colthurst Symons Bristol Road clay pit to Castle Fields works. The engine on this light railway was petrol driven.

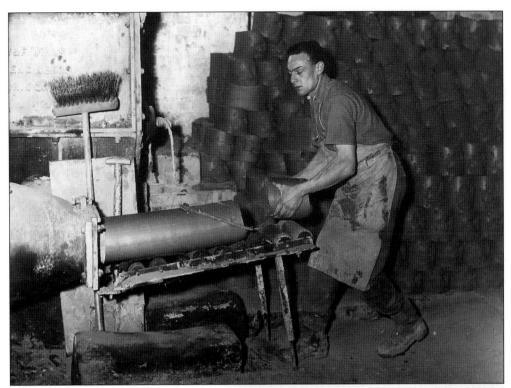

Making tiles - cutting dabs of prepared clay and stacking them ready for the tile moulder to use.

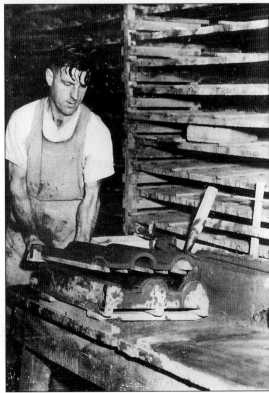

Making tiles - the tile maker lifts a handmade roofing tile from a mould, ready to be placed onto the drying racks behind.

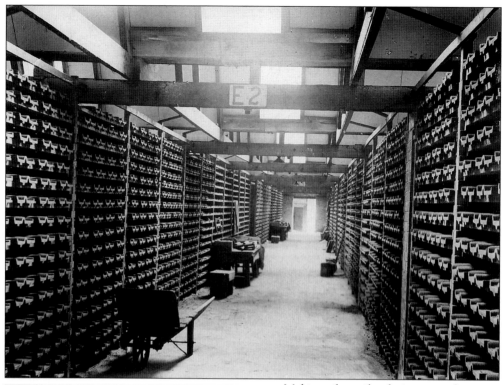

Making tiles - tiles drying on racks before firing at Colthurst Symons Puriton works. Notice the tile moulders' tables.

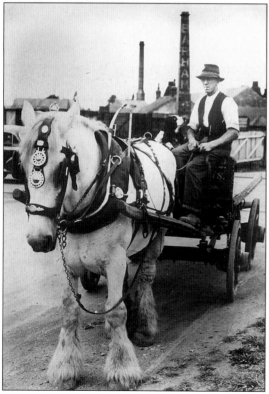

Horse-drawn cart outside Barham's works at East Quay.

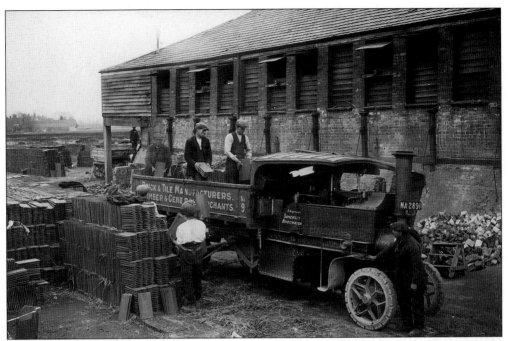

Somerset Trading Co. Ltd; stacking tiles onto a steam lorry. This company was another major manufacturer of brick and tile goods.

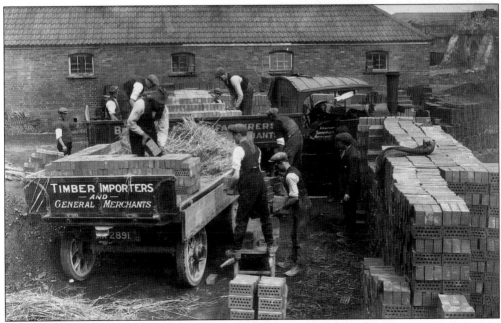

Somerset Trading Co. Ltd; loading bricks onto lorries.

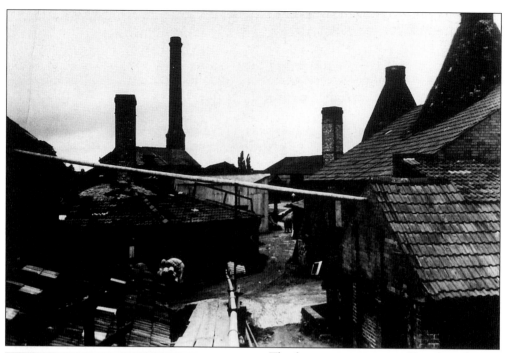

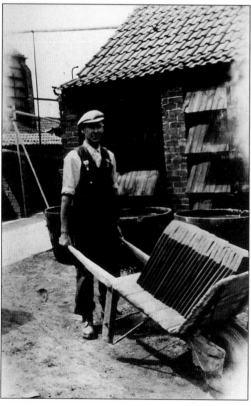

The four images on pages 88 and 89 show Barham Brothers' brickyard, in the mid 1950s. These photographs were taken by the artist Elizabeth Hester as research for her paintings of the yard.

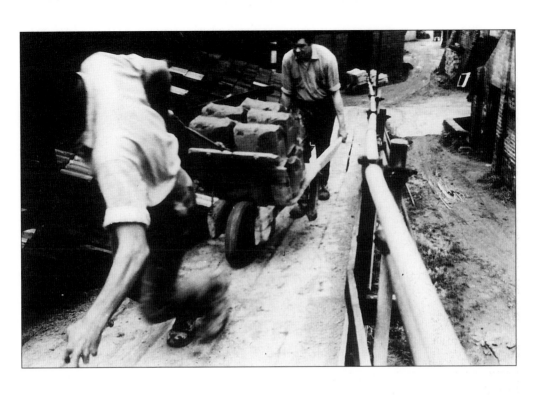

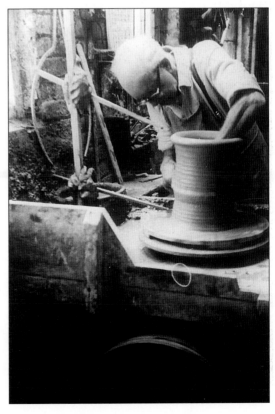

The finished product - Chilton Farm, *c.* 1910. Outside the door to this farmhouse stand a pair of Somerset Trading Co. plant holders. The child in the photograph is Mary Griffiths, whose parents ran the farm.

The finished product - the Woodstock grate from Barham Brothers at Bridgwater.

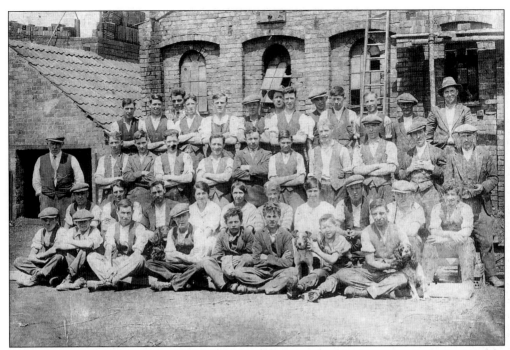

Colthurst Symons & Co. Ltd, *c.* 1928, location unknown.

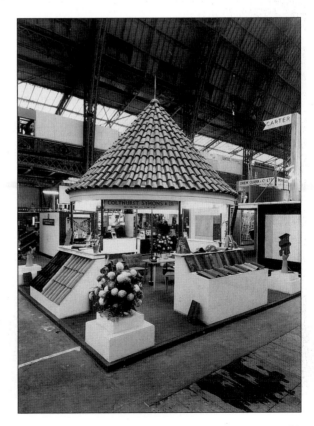

The finished product - Colthurst Symons & Co. Ltd trade stand at the Building Exhibition in 1955. As markets declined and competition from concrete-based products grew, brick and tile manufacturers were keen to demonstrate the versatility of their wares.

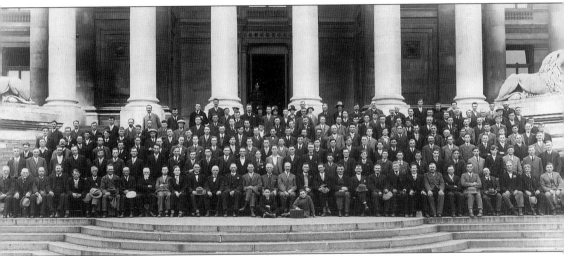

Employees of Colthurst Symons & Co. Ltd, 2 July 1927. This photograph was taken on the steps of Portsmouth Guildhall during an official visit to the city.

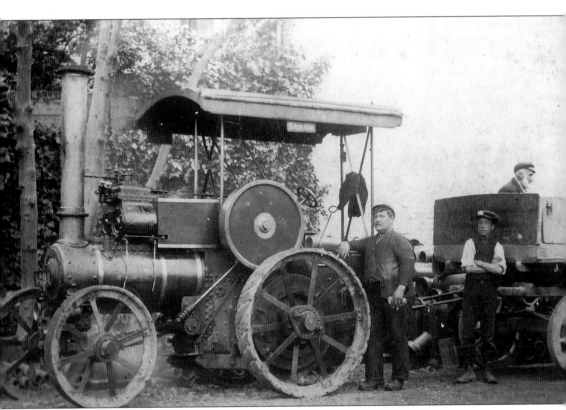

Steam tractor hauling Colthurst, Symons & Co. Ltd wagon, c. 1890.

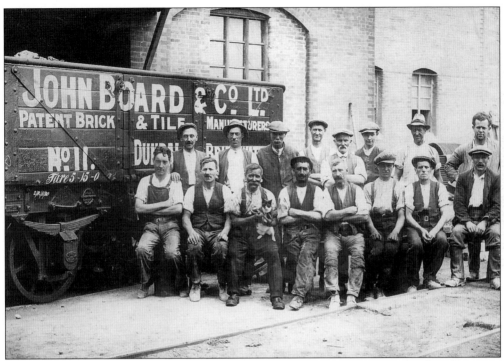

John Board & Co. Ltd, cement works, Dunball, showing the engine room and mill staff in 1928.

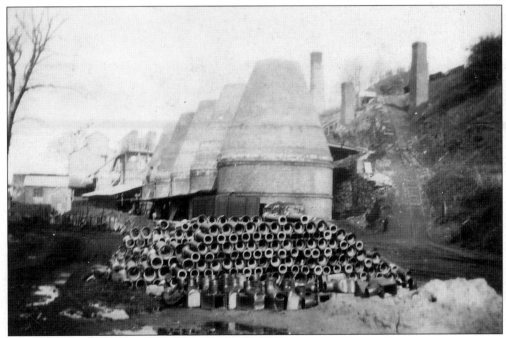

John Board & Co. Ltd, cement works, Dunball, 1928.

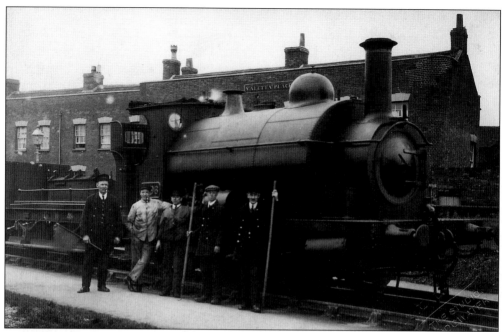

Valetta Place. The engine stands on the branch line to the docks, which crossed the River Parrett by way of the Telescopic Bridge. Left to right: Vic Tolchard, Bert Slade, Harold Hunt, Oswald Shorney and Bert Cridland.

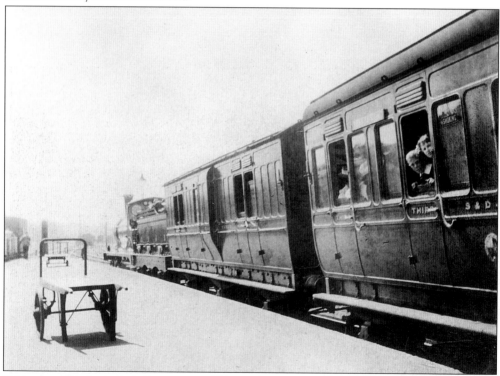

Bridgwater North station, Somerset and Dorset line, 1908. The Somerset and Dorset branch line from Edington opened in 1890. The last train left for Edington in 1952.

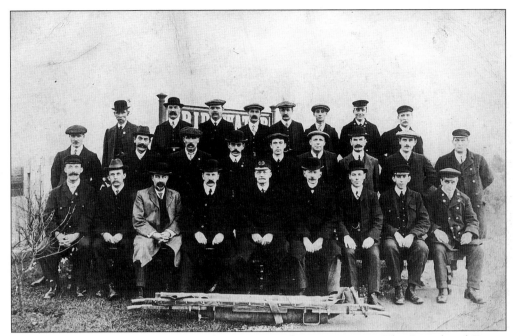

The Great Western Railway First Aid Team at Bridgwater, *c.* 1920. The Bristol and Exeter Railway had reached Bridgwater in 1841 but was taken over by GWR in 1876.

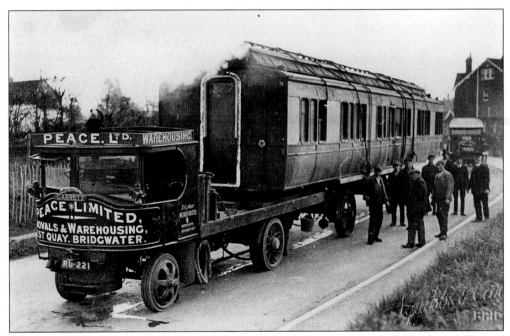

A Peace Ltd steam wagon hauls a rail coach to Bruton along the Quantock Road in 1925.

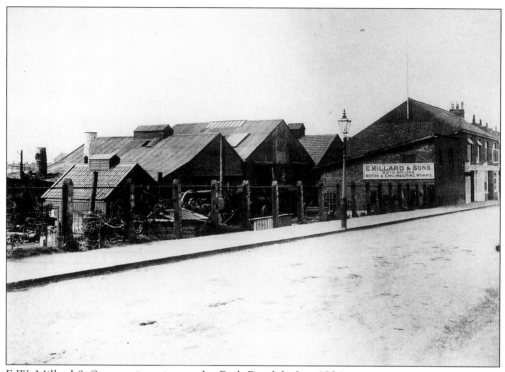

E.W. Millard & Son, engineering works, Bath Road, before 1924.

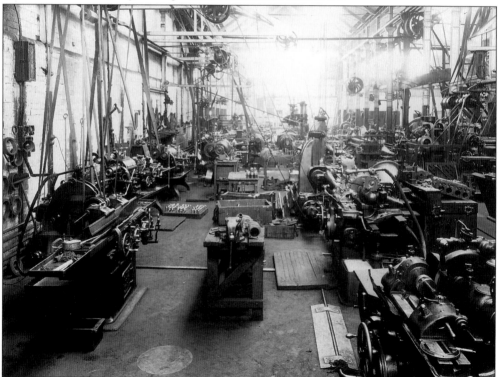

Interior view of the engineering works of W. & F. Wills & Son.

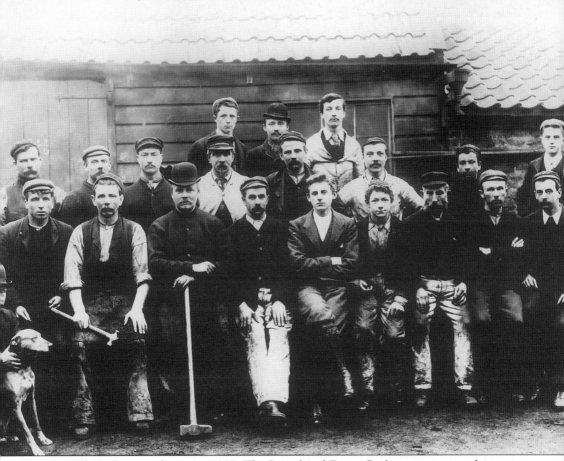

W. & F. Wills & Son, employees, *c.* 1900. The Bristol and Exeter Railway carriage works were based in the town from the 1840s. Their presence bought much associated engineering industry to a town which already had a strong tradition of foundries and other works. W. & F. Wills were based at Polden Street until they moved to Salmon Parade in 1896. They made much of the machinery used in the brick and tile industry. Millards also produced equipment for the brickyards. They were taken over in 1924 by Bale & Sons, and again in 1938 by Evans and Jackson.

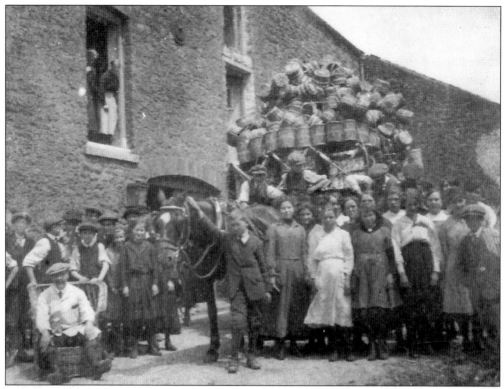

Clarke's wicker works at Chilton Mills, Chilton Street. Mr S.C.F. Clarke from Plymouth opened his works in 1917. Bridgwater was already a major centre for the production of wicker goods.

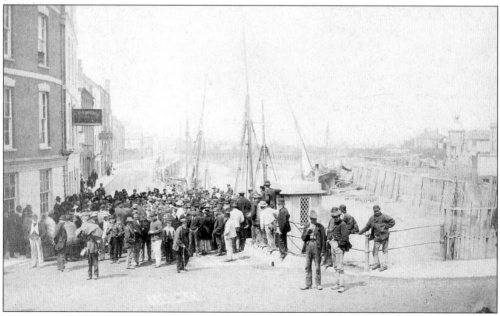

West Quay, Bridgwater. Casual dock workers, or 'hobblers', gathered at the quayside and waited for the call to work as ships docked and set sail.

Nine
Sport and Leisure

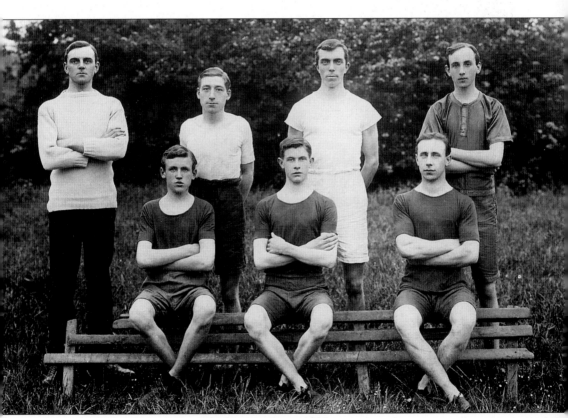

Six young Bridgwater sportsmen with their trainer, *c.* 1910.

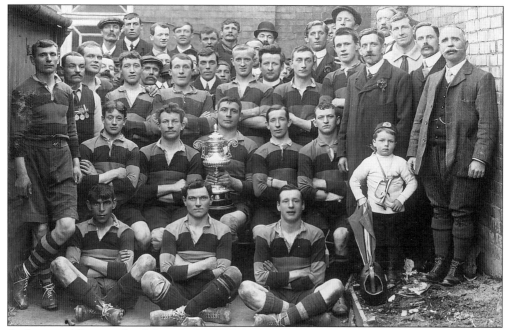

Bridgwater Albion rugby club with the Somerset Cup.

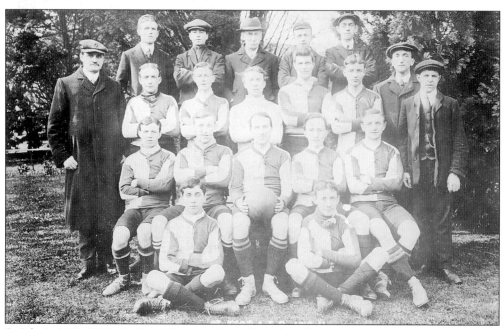

St John's AFC, 1910-11. D.M. Turner is third from the left in the second row.

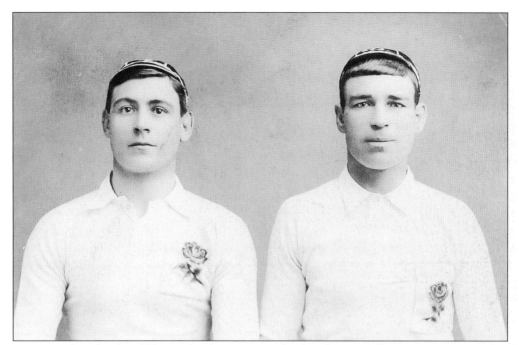

Tom Woods and Bob Dibble, England Internationals of Bridgwater Albion.

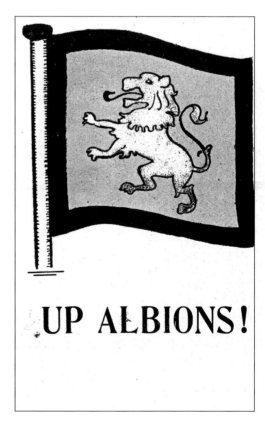

Up Albions! Postcard sent to Plymouth on 13 March 1909. The note on the back reads: 'We lost by 6 points to 5, both their tries absolutely cheated, not fair.'

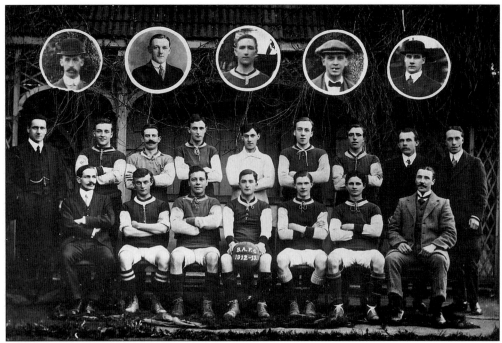

Bridgwater (Town) AFC, 1912-13.

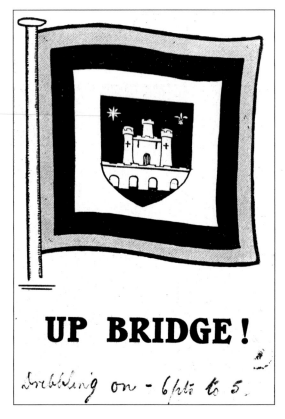

UP BRIDGE !

Dribbling on - 6 pts to 5.

Up Bridge! Postcard sent to Plymouth on 14 March 1909. The note on the back reads:
'It was a famous victory
Proclaim it far and wide
and let all honest sportsmen
Re-echo it with pride
of how "Rattler Roman"
His name immortal made
When he stopped the yellow lion
With his blue and white brigade.'

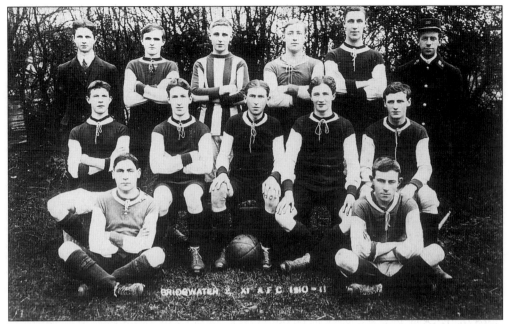

Bridgwater Second XI AFC, 1910-11. H. Clem Turner is at the end of the second row.

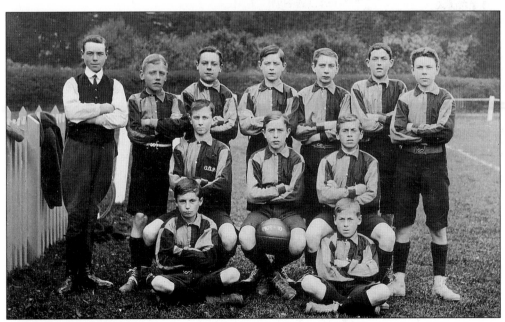

Ashleigh AFC, 1909-10.

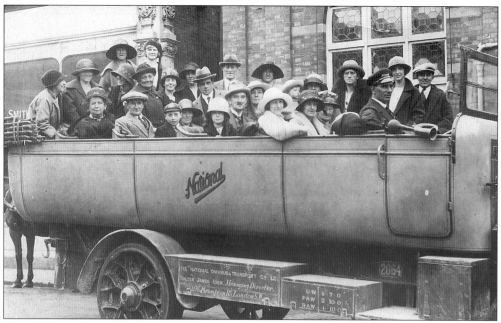

Charabanc outings were popular during the twenties and thirties. The all male group are leaving from The Bath Bridge Inn.

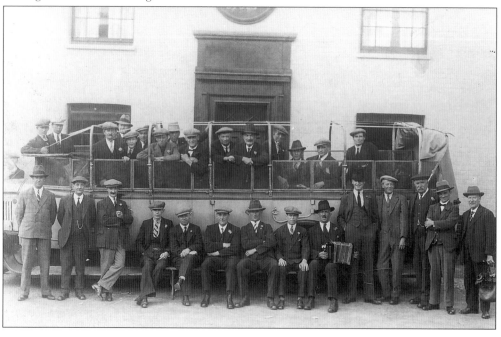

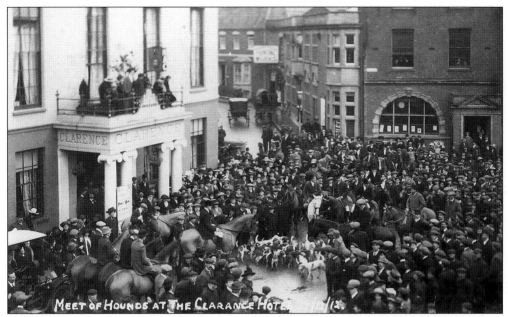

Meet of hounds at the Clarence Hotel, 17 December 1912.

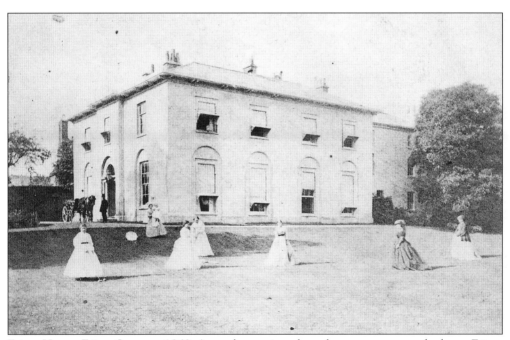

Friarn House, Friarn Street, c. 1860. A gentler pastime than above - croquet on the lawn. Friarn House was demolished in 1962.

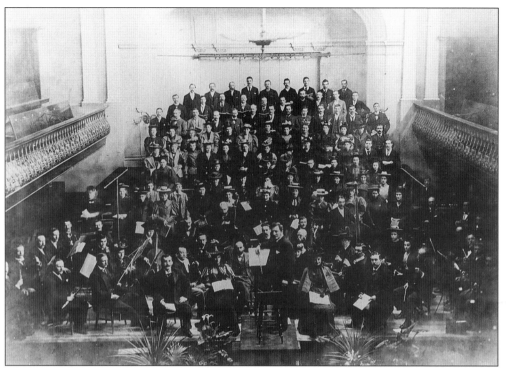

Bridgwater Choral Society, Town Hall, 1898. The conductor, Mr Basker, was a local chemist. The choir gave many popular and enjoyable concerts.

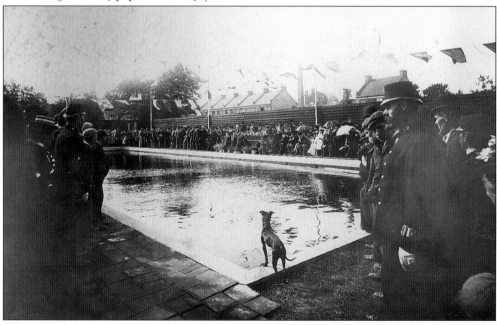

Opening of the Swimming Baths, Old Taunton Road, 21 August 1893. The baths were presented to the town by Councillor W.H. Roberts. There were two open baths, one of which was 'for boys up to the age of 14'. Mr Matthews was the attendant and swimming instructor, aided by his wife who taught elementary school girls.

Ten
Markets and Fairs

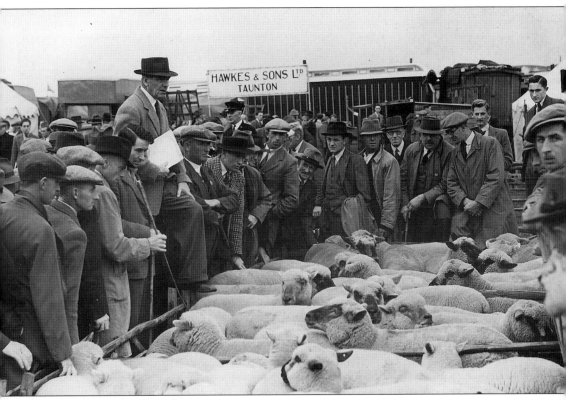

St Matthew's Fair; the sheep fair.

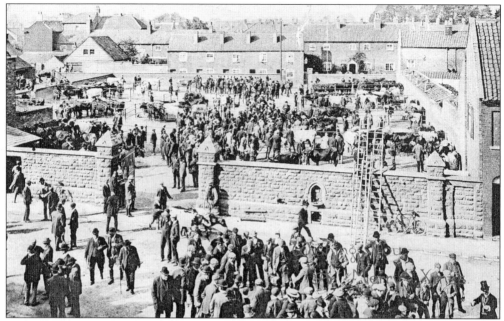

Cattle Market, Market Street, *c.* 1910. This purpose-built market opened in 1877.

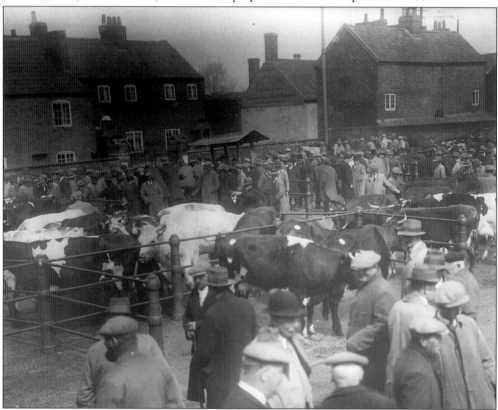

Cattle Market, Market Street, *c.* 1930; 26 June 1935 was the last day cattle were sold here. The market moved to Bath Road and an Odeon cinema opened on this site in July 1936.

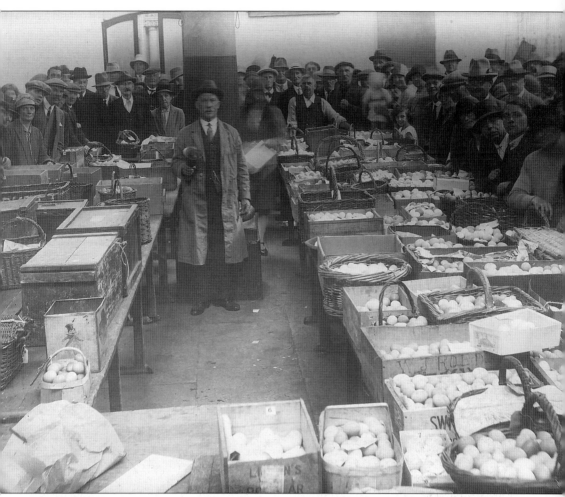

Bridgwater Market House, Cornhill, *c.* 1930.

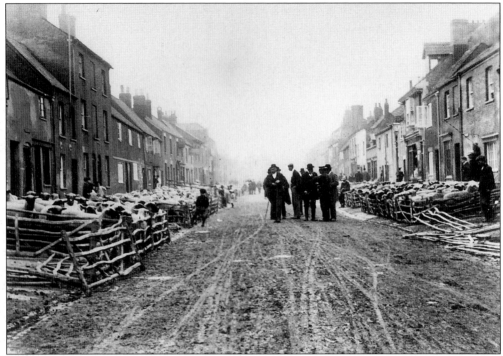

St Matthew's Fair, West Street sheep fair, 1906. Note the street's sloping sides, under the sheep pens.

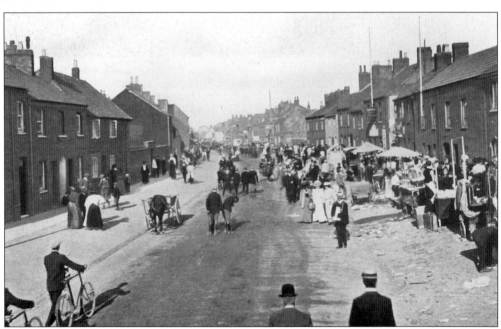

St Matthew's Fair Day, West Street, 1907.

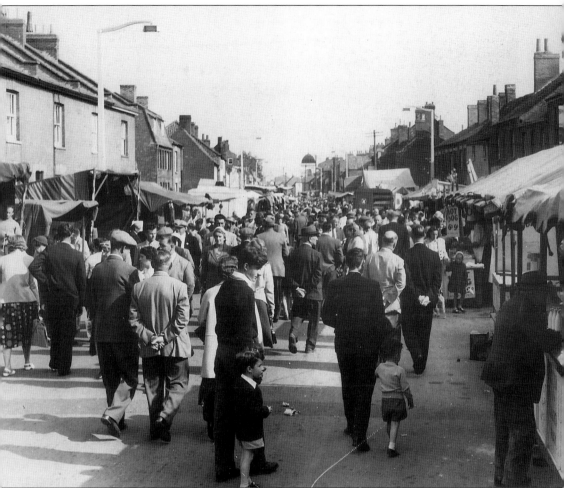

St Matthew's Fair, West Street, *c.* 1956. In 1200 King John granted William Brewer three charters; the third licensed him to hold markets and fairs. From 1249 there was an eight day fair starting on St Matthew's Day. By 1404 it had been moved to a field just outside the West Gate, where it is held to this day. From the photographic record we can see that it has always been an important fair for livestock and horses as well as sheep, but the entertainments have always been there as well.

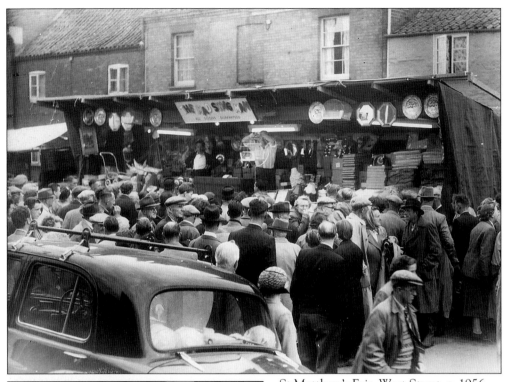

St Matthew's Fair, West Street, *c.* 1956.
The Mad Swag Man draws the crowds.

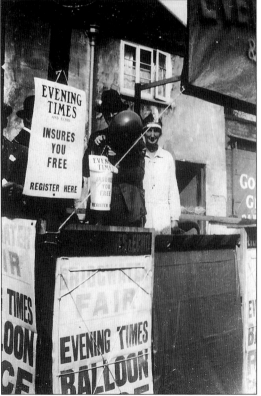

St Matthew's Fair, newspaper stand.
The *Evening Times and Echo* was based
in George Street.

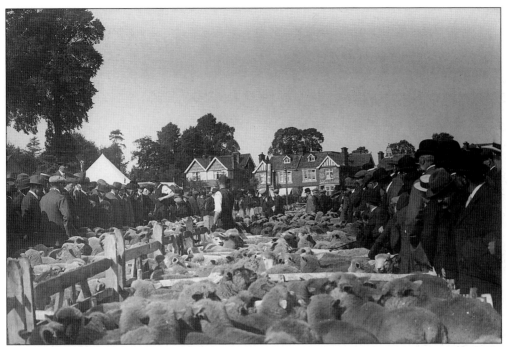

St Matthew's Fair, Fair Field, sheep fair, *c.* 1930.

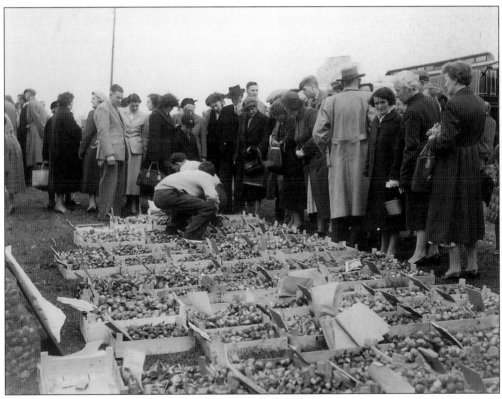

St Matthew's Fair, Fair Field, *c.* 1956, showing a bulb seller.

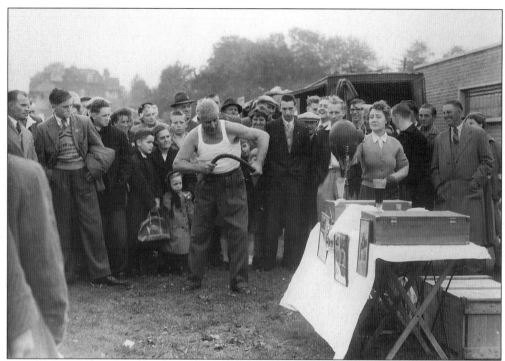

St Matthew's Fair, Fair Field, *c.* 1956, showing *the Strongman* at the fair, whose tonic was guaranteed to improve 'male performance'. Watching in the crowd are Malcolm Wright, Colin Bryant and David Baker.

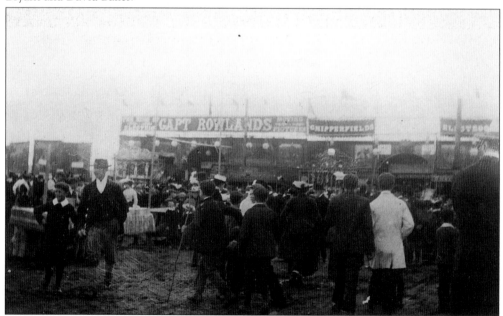

St Matthew's Fair, Fair Field, *c.* 1900. Captain Rowlands was showing 'moving pictures' at the fair from about 1896. Until the first cinema opened in the town in 1910 (the Bijou Theatre in St Mary Street), the fair and other temporary venues were the only places to see the brief ten minute films.

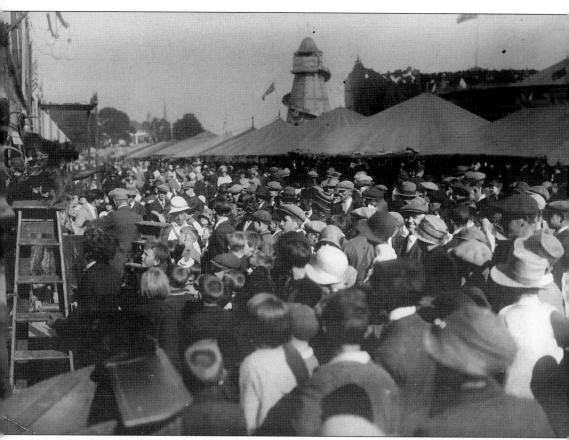

St Matthew's Fair, Fair Field, *c.* 1930. The crowds are drawn to all the excitement on offer.

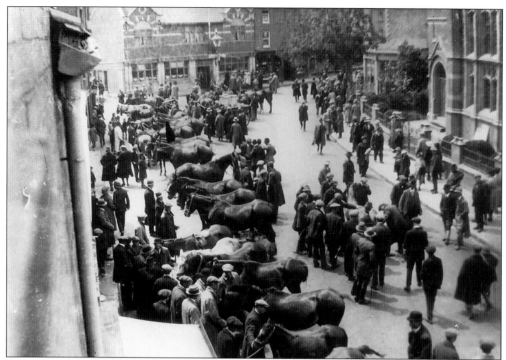

Monmouth Street, horse fair, in the 1920s. The market is being held in front of the Methodist Church which opened in 1911.

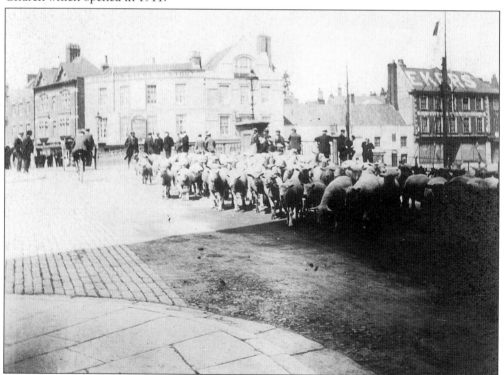

The Town Bridge in 1908. Sheep are being driven towards Eastover.

Eleven
Pageant and Parades

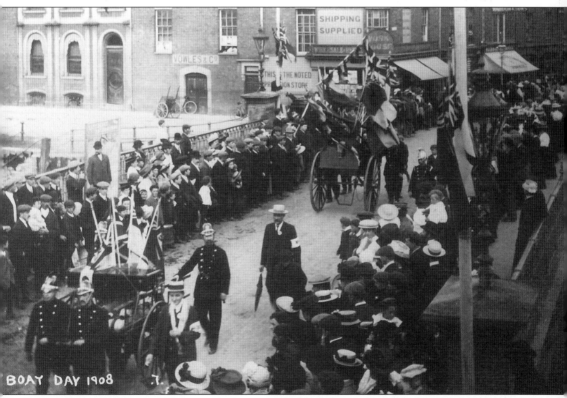

Lifeboat Day, 1908.

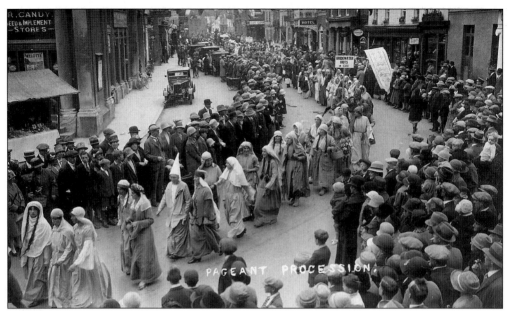

Bridgwater Pageant, High Street, June 1927. Nearly 1,000 performers took part in the pageant parade and show held at Sydenham Manor.

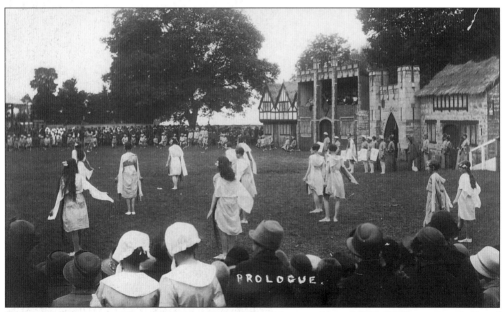

Bridgwater Pageant, The Prologue, Sydenham Manor, June 1927. Different periods of Bridgwater's past were re-enacted in the grounds of the seventeenth-century manor house. Major scenes included: Admiral Blake, Sedgemoor, the Peasants Revolt in 1381 and St Matthew's Fair in 1588.

118

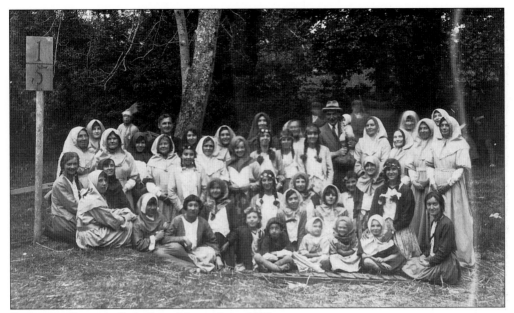

Bridgwater Pageant, Sydenham Manor, June 1927.

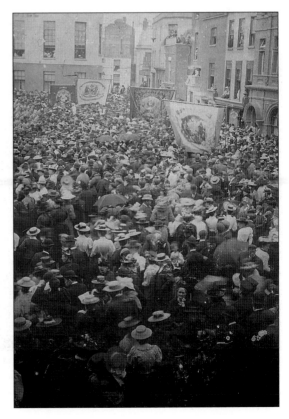

Cornhill, c. 1895-1900, showing a
friendly society or trade union rally and
parade. Whatever the occasion, a parade
always seems to draw a good crowd in
the town.

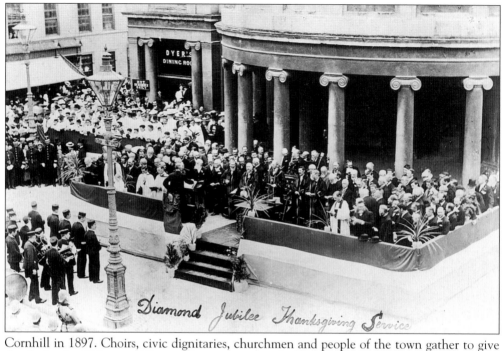

Cornhill in 1897. Choirs, civic dignitaries, churchmen and people of the town gather to give thanks for the 60th year of Queen Victoria's reign - the Diamond Jubilee.

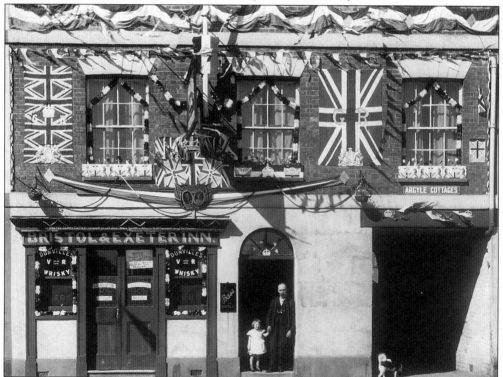

St John's Street, 12 May 1937. The Bristol and Exeter Inn celebrates the coronation of King George VI. The landlord was Walter James Cattle.

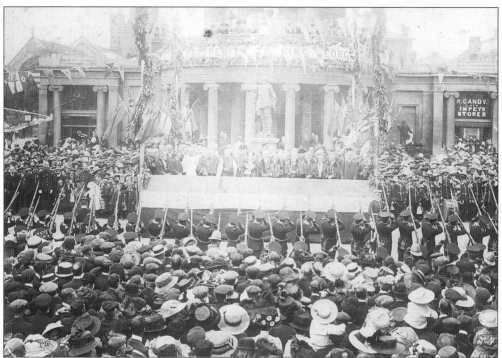

Cornhill in 1910 and another royal occasion - the proclamation of George V as King.

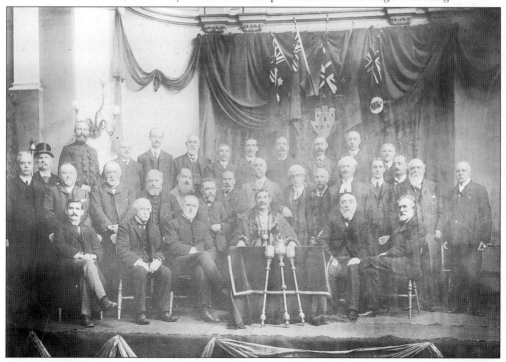

A record breaking mayor. Henry W. Pollard is pictured here surrounded by fellow members and officers of the town council. By 1906 he had been mayor six times, and was to hold office again in 1910.

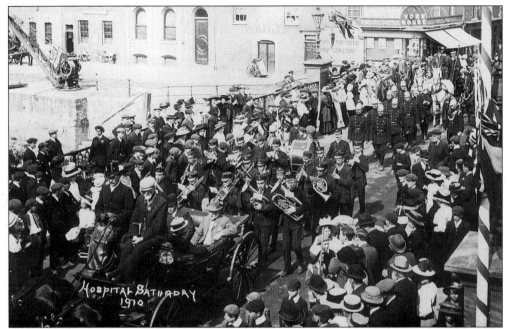

Hospital Saturday, July 1910. This annual cavalcade, in aid of the Hospital Saturday Fund, always drew large crowds.

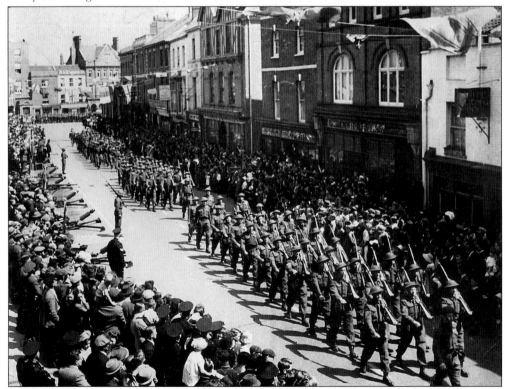

High Street, VE Day parade in 1945. The end of the Second World War in Europe was celebrated with a grand parade of soldiers, the home guard, air raid wardens and others.

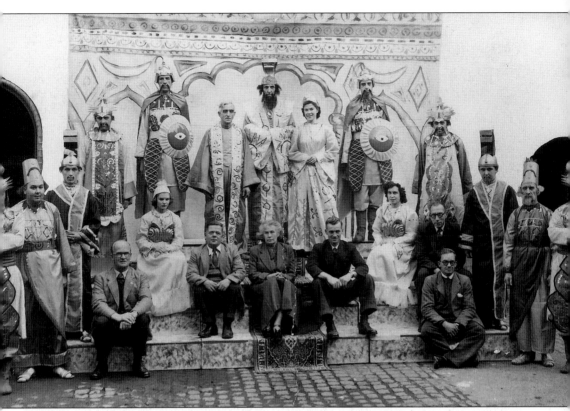

Bridgwater Carnival, Gremlins Carnival Club, 1952. The origins of the carnival date back to the 1605 Gunpowder Plot, with Bridgwater traditionally marking the occasion with a large bonfire and fireworks on the Cornhill. Unfortunately new road surfaces proved unsuitable and the last bonfire was lit in 1924. Locals dressed in costume paraded around the town. The 'gangs' moved onto other forms of transport - the horse-drawn wagon - and the parades became much more organised.

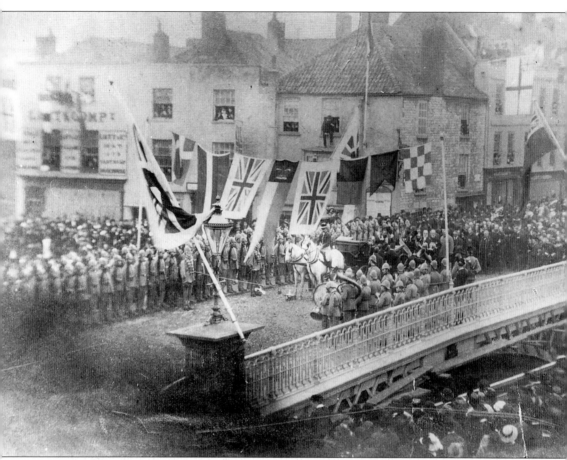

The opening of Bridgwater Town Bridge, 5 November 1883. The first 'officially' organised procession seems to have been in 1857, to celebrate the crushing of the Indian Mutiny. There were others in 1881, 1882 and again in 1883, following the opening of the bridge by Mrs Holland. The following year yet another spectacular carnival was organised and since 1909 they have been held on the first Thursday in November each year.

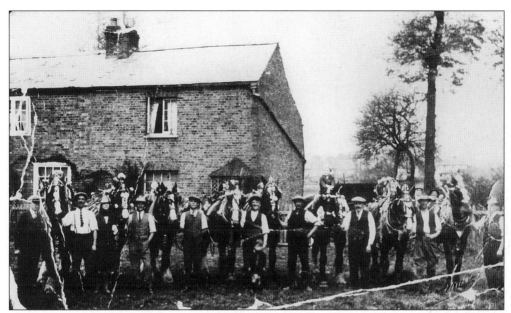

Carnival horses, *c.* 1920. These beautifully decorated horses pulled the carts for the carnival. Light was provided by paraffin torches. They were gradually replaced by tractors after the Second World War.

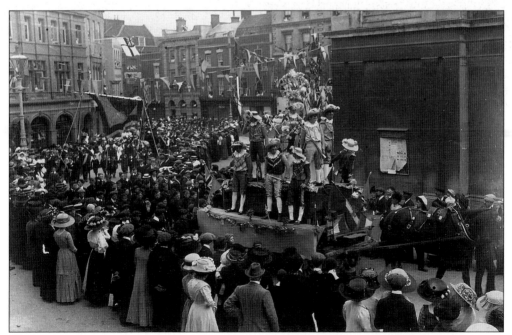

Coronation Procession, 22 June 1911. The coronation of George V was celebrated with a Carnival Style parade.

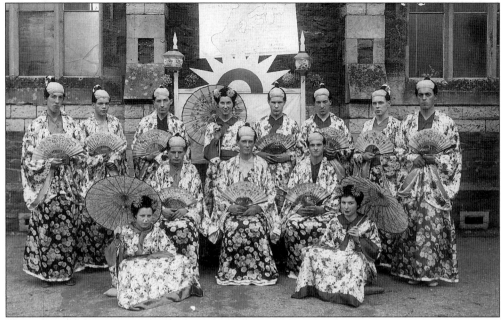

Bridgwater Carnival, Gremlins Carnival Club, 1937. The winners of the Bryer Cup. Back row from left to right: ? Pear, F. Hooper, ? Parr, ? Betty, R. Williams, L. Biddiscombe, F. Fursland, ? Baker. Front row: D. Sheers, W. Manchip (captain), A. Searls, M. Williams.

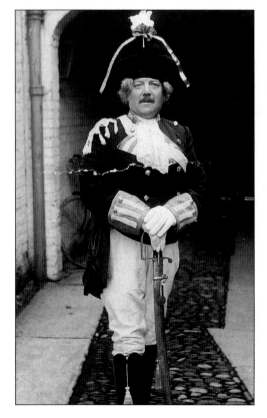

Mr G. Merrett, landlord of the Devonshire Arms, Eastover, from 1914-1941. The pub was home to the Devonshire Arms Carnival Club. It closed in 1963. Many carnival clubs are based in local pubs and clubs.

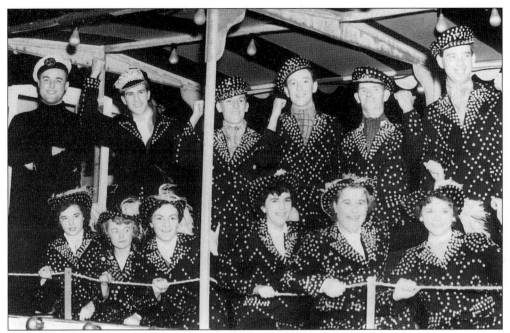

Bridgwater Carnival, Gremlins Carnival Club, 1955; *The Gay Pearlies*.

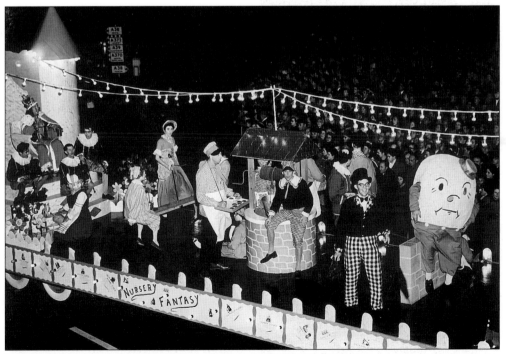

Bridgwater Carnival, Gremlins Carnival Club, 1956; *Nursery Fantasy*.

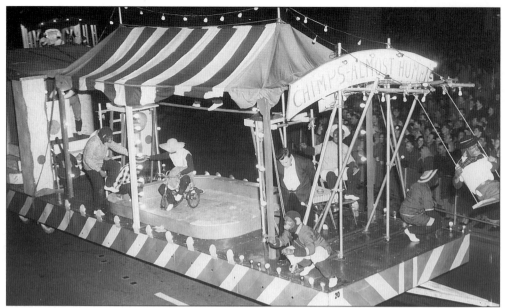

Bridgwater Carnival, Gremlins Carnival Club, 1957; *Chimps almost Human*.

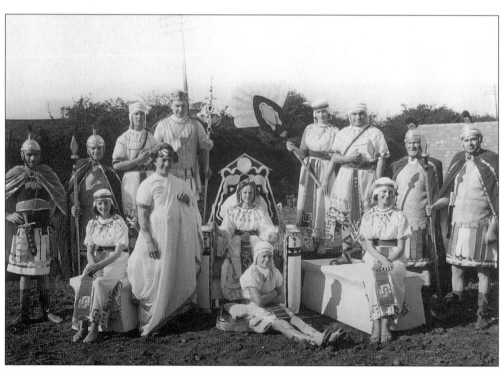

Bridgwater Carnival, Hardy Spicer Carnival Club, 1951. The entry *Caesar at the Court of Cleopatra*, won first prize at Bridgwater, Highbridge and Wells Carnivals. Back row from left to right: P. Woodman, L. Salter, W. Grandfield, F. Bowey, Miss Woodman, S. Nash, F. Russell, J. Letherby. Front row: Miss Adams, B. Bell (captain), Miss Jean Russell, Miss Joan Russell and seated in front is Peter Bell.